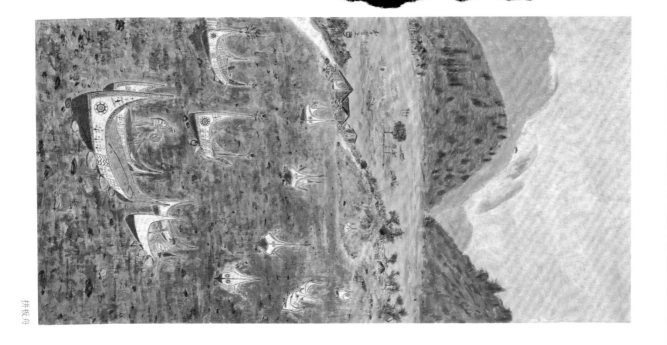

拼板舟

返回自然之夢

羊角扶搖上

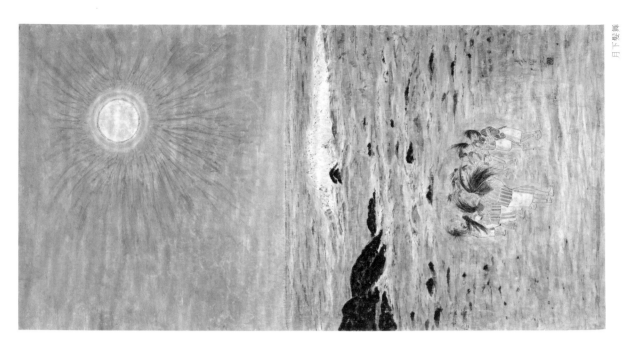

月下髪舞

李賢文　每幅130×65.5cm
2016-2017 | 虎皮宣・彩墨

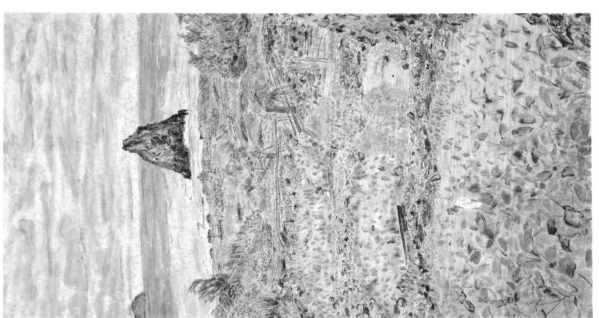

水芋田

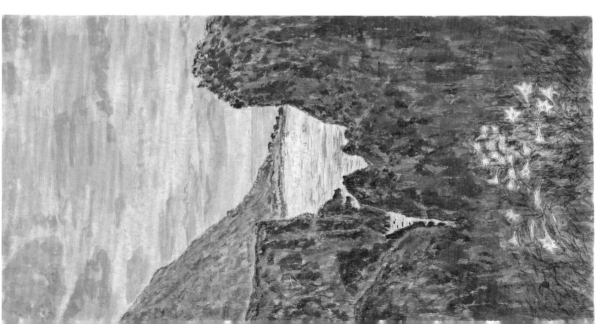

野百合

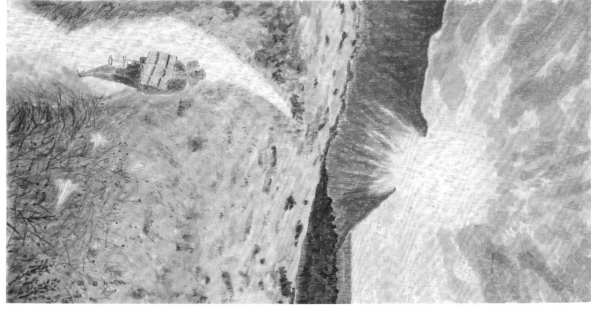

日出青青草原

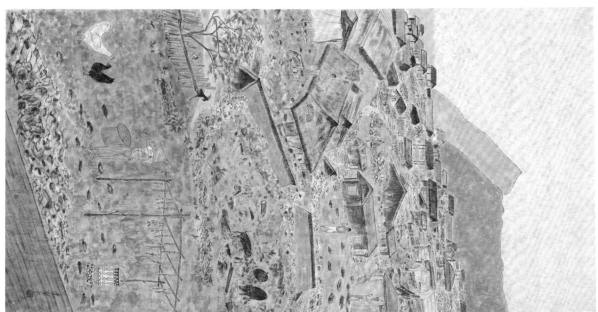

野銀部落

達悟勇士

返回自然之夢 —— 蘭嶼組曲
Dreaming Back to Nature — Orchid Island Suite

返回
自然之夢

Dreaming
Back to Nature——
Paintings by Lee Shien-Wen

———— 李賢文畫集

國立歷史博物館
National Museum of History

返回自然之夢
—— 李賢文畫展

　　李賢文先生，1947年生於臺北，《雄獅美術》創辦人。中學時期即喜愛繪畫，於師大附中成立寫生會。1992年起隨陳雲程、張光賓等知名書家學習書法，1996年後從書法進入水墨畫的學習創作。

　　他以豐厚的文化藝術素養，加上長期關注臺灣自然環境之變遷，一遍遍攀登臺灣各大山嶽與美麗大地，以水墨為媒材寫生山水，引書法入畫，摻以西畫造型，畫中透露出不同於傳統山水畫的清新氣息，流露出一種閒雅的文人畫風。近年來，先後舉辦的多次繪畫展覽，如2004年與盧廷清、鄭治桂在臺北福華沙龍聯合舉行「群玉山頭」畫展，2011年與張光賓老師舉行「蒼樸‧清曠‧筆墨情」雙人展，2012年在中央大學藝文中心舉行「人間清曠」水墨個展。讓他的藝術生涯更顯完備。

　　李賢文先生的繪畫著眼於生活、自然的觀察，並以人文關懷的態度去營造畫面的氛圍，藉著筆尖靈動的起伏，鋪陳著對社會的種種期待。畫面所強調的審美經驗旨在體現自然的美好與時間流變，由此而發掘人與自然之間的微妙互動。作品有著如一的藝術理念，沒有塵囂的抗議議題，也不見過多虛幻的浪漫情調，只是真誠地畫出這塊土地的諸多美好與記憶。

　　所謂「外師造化，中得心源。」寫生山水，於外汲取周遭自然養分，於內思索生命本真。在智識與體驗相結合下，讓情思轉之於筆墨，藉由外在風物景象的描摹，展現主體對於天地自然的感察、體悟。這次【返回自然之夢】展出李賢文先生近年作品35組件，可以看見藝術家鮮明的個人面貌，相信從中亦能感受畫家對土地的情懷。

Dreaming Back to Nature
—— Paintings by Lee Shien-Wen

Born in Taipei in 1947, Lee Shien-Wen is the founder of the Lion Art. His love of painting was first kindled during his high school years, and he founded a society of outdoor sketching in the Affiliated Senior High School of National Taiwan Normal University, where he was studying. Since 1992 he has been studying calligraphy with famous calligraphers like Chen Yun-Chen and Chang Guang-Bin. Since 1996 he has extended his creative career from calligraphy to ink painting.

With a solid cultivation in culture and art, along with his continual care for the natural environment of Taiwan, Lee Shien-Wen has climbed all important mountains in Taiwan and created many landscape sketches with ink wash. In his works, we can see how he integrates calligraphy with formative techniques of Western painting. A fresh spirit emanates from his works that is different from the traditional landscape painting; we can detect a leisurely literati style in his works. In recent years, he has presented his works in several exhibitions. In 2004 he joined Lu Ting-Ching and Cheng Chih-Kuei in a joint exhibition *The Tip of Mount Jade Trio Exhibition* in Howard Salon, Taipei. In 2011, he and Chang Guang-Bin presented a joint exhibition *Simplicity Meets Ethereality: A Passion for the Spirit of Painting*. In 2012, he presented *A Path to Hidden Beauty - Lee Shien-Wen's Solo Exhibition* at National Central University's Art & Culture Center. His artistic career grew more complete through these exhibitions.

Lee's paintings focus on the observation of life and nature. He arranges his composition with a humane concern. His brushstrokes speak out his expectations for the society. The aesthetic experience built up in his imageries aims to highlight the beauty of nature and the changes of time. In this way he explores the subtle interaction between human and nature. We can find a unified ideal of art in his works without any jarring note of complaint or intangible romantic sentiment. He simply depicts his many beautiful memories of this land with a deep sincerity.

As one saying goes, "while the external nature serves as the teacher for the artist, the true art must be created via artist's own heart." Lee Shien-Wen has travelled and sketched in nature, absorbed spiritual nutrient from the external world, and reflected on the essence of life in his heart. Combining intellect and experience, he transforms his thoughts and feelings via brush and ink into works that show observation, reflection, and experience of nature. This exhibition presents 35 sets of recent works by Lee Shien-Wen, illustrating his vivid personal styles and he deep care of the land and nature.

Teng-Chin Chen

館
序

Dreaming Back to Nature:
Paintings by Lee Shien-Wen

Director's Foreword
／Chen Teng-Chin·········002

Curatorial Statement
／Tsai Yao-Ching·········006

Artist Statement
／Lee Shien-Wen·········012

Table of Content

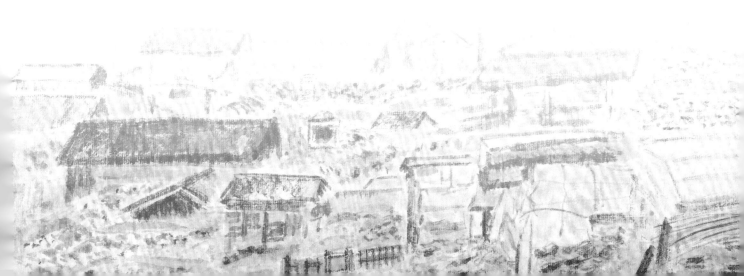

自然、人文與美學

——李賢文的水墨畫語 ｜ 蔡耀慶

「美術作品的價值高低，就看它能否借極少量的現實界的幫助，創造出極大量的理想世界出來。」——朱光潛《與美對話》

李賢文先生是國內知名的藝術工作者，也是個人敬佩的藝壇前輩。他的藝術之路前段著力於藝術訊息的傳播：1971年起創辦《雄獅美術》，持續至1996年。每月一刊的雜誌，以寬容平和的角度向國人介紹西方藝術思潮，讓讀者可以了解當代藝術的發展狀況；同時也以正面鼓勵的心態推廣臺灣藝術作品，讓新舊藝術家得以受到重視。這本藝術刊物，對臺灣美術發展注入許多心血，影響重大。雜誌停刊後，他本著追求藝術的初衷與熱情，續以書畫自修，經歷佛學、打坐的修行，讓他發展出特有的水墨寫生繪畫創作風格，記錄土地和表達生活感想。近二十年來的成果，便是一幅一幅讓人回味再三的水墨作品。

對他而言，兩段不同性質的工作都是完備藝術理想的必經過程。他把人生最精華的時段為雜誌努力，因為出版工作對他而言，是「蘊蓄著對本土藝術無止盡的熱情」；決定停刊並非離開藝術圈，而是「想找回對藝術的熱情」。可見無論是筆耕或是手繪，都是本著藝術理想而進行的重要工作。此次在其不逾矩之年，挑選近年藝術創作，以【返回自然之夢】為名辦理展覽，從中看到他藉由繪畫語彙闡述個人對這塊土地的情懷。

籌辦此次展覽活動的機會，可以先睹作品風采。觀看所選作品，語彙豐富多元，畫作中水墨與色彩的交融，流露出一股恬淡。繪畫題材隨處可見關心土地、環境狀況，畫中題記則見到故實的記載與畫家對於自然美學想法，既是完備了畫作，也闡述著畫家深切的人文關懷與對美的追求。於此因緣，擬以短文略述個人些許觀察，作為學習記錄。

一·自然與寫生

我們對水墨所描繪的山川景色有著何種期待？孔子曰：「智者樂水，仁者樂山。」文人眼中，山不是單純的山形，水也不是只有流淌。山和水是情思中深刻的感受，如山的境界、似水的情懷其實就是心中審美追求。莊子曰：「天地有大美而不言，四時有明法而不議，萬物有成理而不說。」★01提醒我們「美」就存在天地自然之間。選擇寫生作為連結天地萬物間省察自我的工作，是在山境、水情的審美追求中，用筆墨實踐其精神。

南齊謝赫的六法之說，將「氣韻生動」排在首位，表示繪畫首要表現目的便在追求一種氣韻。山水畫中的

氣韻所由，無非對自然深切觀照，唐志契在《繪事微言》中說：「凡學畫山水者，看真山水極長學問，便脫時人筆下套子，便無作家俗氣。」★02意味藉著親臨其境，師其精神，方能達其氣韻。寫生的目的是向自然學習，無需抱著固有的模式，容許創造性和靈活性，開拓自身的繪畫活路。

李賢文的繪畫面貌是從寫生開展。他自中學對繪畫產生興趣，高中時期創辦學校寫生會，與友朋揹起畫具走出戶外對景寫生，自然之美成為他創作的源頭與主軸。臺灣的名山勝景，讓他一次次走向山林，細察山川之美，借著畫筆把眼睛即時看到的美好山河繪製而出，一舒胸中塊壘；將人文情懷付諸其中，為真山實水傳神寫照、傳情達意。此刻畫中所見，如山的雄偉沉穩、水的縹緲靈動、樹的瘦勁挺拔、人的娛情遣興，便非只為畫面安排，更像是人生體會。

營造整體效果的基調是不落窠臼的筆墨表現。那由水彩筆與毛筆不同特質所交織出來的筆調，讓整體畫面有所起伏而不會過於沉重。以往寫生多用鉛筆打底而後著色，書法學習之後，改以毛筆銜接過往寫生經驗。此一筆法變動，是從硬筆轉至軟毫，筆觸中產生更多粗細變化。再者，寫生本就面向實物，臨寫觀摹，自然物件呈現面貌並非規格化安排，也就無須刻意採用傳統疊石架山的皴擦成形。在畫作〔虛曠為懷〕中，體現他筆法的諸多面貌，點、線紛陳，純以墨色鋪排成型，畫面的輕重、疾緩，自出機杼，力圖從線條的輕重中表現流動的韻律。由此可見在他手中，筆墨運用與傳統水墨有著承繼又不盡一致的邏輯。

畫中「以線造形」不是依靠線條簡練地摹形傳神，而是注重線條本身的韻味和韻律，亦即是筆法的追求。在書法的練習過程中，熟悉毛筆使用方法，可以逐漸體認內蘊精神；且書畫相通之論，提醒著畫家，在處理繪畫技巧時，也可從書法不同書體的練習中獲致。這些筆法概念，李賢文實有所感，他在《觸賞自觀》寫生冊的創作意念中，便說：「行草般的墨線細綴花串，以古隸體的堅實寫莢果，而葉片參差其中，如魏碑似楷體。」★03誠然，書與畫是可以交流的兩端，書法的學習會影響繪畫創作，學習碑帖所帶來的養分，不只為題款需要，還能藉由碑帖字體外在形象的觀察，感受線條的質感，進而揣摩完成的筆法而後用於創作實踐。毛筆的提、按，讓線條具抽象美感，處理物象之時，內含結體的變化，又糅合繪畫造型的描摹，使得畫作猶若剝蔥，層層味濃。作品〔玉山有待圖〕，是畫家造境之作，中景、遠景筆法多樣，反映出抽象美感的變化。筆下於輕重有所著眼，勻淨而厚穩，透出一種濕潤感。筆觸與山川的情境和生態格調和諧如一，讓畫面彷彿有了異常清新又豐潤香馨的味道。

筆墨趣味中的色澤，是「墨分五色」的概念。水、墨的乾、濕混搭與動作的皴、擦、披、削等等，顯示造型與寫意的韻律。在李賢文的作品中，雖不多見皴擦技法，然於墨色變化、輕重卻不馬虎，作品《玉山曉月》前景諸山，全賴墨色成就，構思不止於單一的排比，精細布局空間內採用單一用墨格調，不同的布局

★02——唐志契《繪事微言》
收錄於《中國畫論類編》下冊
（北京：人民美術出版社，1986年），頁733。

★03——李賢文《人間清曠》
（臺北：雄獅美術，2012年），頁26。

空間則用不同的用墨格調區別，讓墨色的變化形成階差，於效果上能與用筆格調相搭配。這是一種帶有設想的佈置與設計，使筆墨不僅確實合一，也因為作者主體的藝術思索，消除用筆、用墨的隨意流宕之感。

畫家接引西畫技巧，精巧的用色效果，讓畫面更多趣味。因為抽象化的筆墨雖是對自然的濃縮，讓描繪山水人文時，賦予個人所埋解意味，但也讓自然原有的豐富色質美感有所失去，運用色彩恰可補足此一缺憾。加之過往西畫基礎，擁有的色彩經驗，可以注入黑白世界，讓水墨創作增添姿態。在作品中，不乏設色作品，多於筆墨基調上因景、因物，敷彩設色。如作品〔貓空百年茶事〕和〔泉自奔忙月自遲〕是一種淡彩設色的畫作，畫面營造出山色秀美，風柔草鮮的樣態，通幅作品彩度淺淡，用色既有分別又有過渡，在清雅的背景中突出了人物的穿梭，成功的表述場景的存在。而〔利稻曙色〕則表現出一種墨重沉沉的氛圍，場景發生在黎明尚未到來之際，畫家筆下的大地、山石、近景、遠山到底色，如恨其不重似的，筆筆沉著，將畫面格外鮮潤厚重，韻味悠長。

二‧自然與逸格

歷來畫論對於自然與逸格多有討論，李賢文畫作之中的清曠逸趣，甚是符合此一理路。

繪畫重視自然的想法，是文人畫作相當重要的思想脈絡。水墨繪事崇尚自然美學，在唐代王維《畫學秘訣》云：「夫畫道之中，水墨最為上，肇自然之性，成造化之功。」[04]清楚標列出水墨乃是追求自然的旨趣；張彥遠的《歷代名畫記》推重「自然」，將之列為繪畫的最高品第；朱景玄在《唐朝名畫錄》提出：「不拘常法，又有逸品」[05]之論，強調藝術創作不落規矩法度的難能可貴。

郭熙在《林泉高致》一書中，說道：「欲奪其造化，則莫神於好，莫精於勤，莫大於飽游飫看，歷歷羅列於胸中。」[06]說明山水畫作是因為畫家有面對自然的深刻認識，能夠從自然中體認奧妙，從而轉化成為畫面，成為好的作品。北宋黃休復承繼自然為上的審美觀，在《益州名畫錄》中強調「逸格」，謂：「畫之逸格，最難其儔，拙規矩於方圓，鄙精研於彩繪，筆簡形具，得之自然，莫可楷模，出於意表，故目之曰逸格爾。」[07]這個逸品在神、妙、能三品之上，是據理於「得之自然」的美學思想；蘇軾，同聲相應地提倡「天工與清新」的審美意趣，並極力推許王維所揭櫫的水墨畫創作。他和米芾那種率性自然而不主故常的作品，雖說是文人閑暇時遣興的墨戲，卻恰恰切合黃休復對「逸品」的要求。韓拙的《山水純全集》就提到：「今有名卿士大夫之畫，自得優游閑適之餘，握管濡毫，落筆有意，多求簡易而取清逸，出於自然之性，無一點俗氣，以世之格法，在所勿識也。」[08]可見對「逸品」的重視。

★04——文本載於王維《王右丞箋注》卷二十八。
另有以《山水訣》收錄於《中國畫論類編》上冊
（北京：人民美術出版社，1986年），頁592。

★05——朱景玄《唐朝名畫錄》收錄於《中國畫論類編》
（北京：人民美術出版社，1986年），頁22。

★06——郭熙《林泉高致》收錄於《中國畫論類編》
（北京：人民美術出版社，1986年），頁632。

★07——黃休復《益州名畫錄》收錄於《畫史叢書》第三冊
（臺北：文史哲出版社，1983年），頁1377。

★08——韓拙《山水純全集》收錄於《中國畫論類編》
（北京：人民美術出版社，1986年），頁676。

明代董其昌延續張彥遠和黃休復的美學思想，於繪畫論述中肯定「逸品」的審美理想，在《畫禪室隨筆》中，提出：「畫家以神品為宗極，又有以逸品加於神品之上者，曰出於自然而後神也。」★09讓「逸」的意涵上升至精神的追求。借用佛家「南北分宗」的說法，將「南宗」脈絡連結到王維以自然為上的水墨面貌，從而建立文人逸品的歷史源流。此中「逸格」並非了了幾筆的恣意作樂，任筆揮灑，而是體察自然萬物後的萃取精華，以抽象的筆墨，表現出似與不似的流動。此次展品中的〔螢光如織〕、〔螢光如流〕，正合此一意趣，畫面上山形隱約，幾處留白如有螢光點點從中透出，既像是山中之景，又像是夢幻之境。

無疑地，帶有冥想式的風景書寫，讓作品有著與傳統水墨大相逕庭的表現取向。加上寫生時的視角選擇，讓作品除了接納傳統水墨多點透視、營造出可居、可遊的畫面之餘，企圖讓當下的觀看經驗也保留在畫面之中。如同畫作〔走過一甲子〕所展現畫面，並非當下此刻的寫真，而是將今日實況與過往照片，兩段不同時空的形象凝結為一。畫家有意地讓時空意涵的討論停駐在這件大立軸中，瀏覽畫面，如同面對時間流變，目光移動間，正似回顧了六十年的轉變。生命中的種種趣味，是發生於我們生活周圍真實發生的片段，基於藝術與日常生活應當合而為一，而將之轉為藝術表現，也就能美化人生。

徐復觀先生在《中國藝術精神》中對逸品繪畫有精闢的論說：「超逸是精神從塵俗中得到解放，所以由超逸而放逸，及逸格中應有之義。」★10是以繪畫中的「逸格」並非只是技巧呈現，而是精神追求，是立基於畫家對於自然的理解，經過多元的深層思考，將心中的面貌透過繪畫手段重新演繹出來，讓畫面產生不流時俗的清新。

三・自然美學

近年來，「自然」的意義受到重視，談論「自然美學」的風尚也相對興盛，這一來是擴大美學的範圍，再者，也是對人類破壞、污染大自然的反思。自然美學研究提醒我們：世間原本長存著善與美，研究成果提供我們如何欣賞自然，接受自然指引，進而啟發環保行動。誠如環境倫理學者歐思磊（Max Oelschlaeger）所說：「環境倫理的目標，在於批判主流的世界觀並提出替代性的世界觀。這種轉變，並不是去『創新』，而是要『喚醒古老的智慧』。」可見自然美學希冀由被動地沈思轉向對自然世界的保護。

誠然，觀看自然之時，更像是誠實地面對自己。即使畫家以創作為己業，然而藝術家亦處在環境污染、資源耗盡、生態破壞、氣候變遷，人與自然的關係日益緊張，人類的生存處境正面臨前所未有的挑戰。這些問題的解決方式，是將畫作鑲嵌於自然之中，風景變成是模態變化、平臺、系列，風景如同人，被鑲嵌

★09—— 董其昌《畫禪室隨筆》收錄於《中國畫論類編》（北京：人民美術出版社，1986年），頁722。

★10—— 徐復觀《中國藝術精神》（臺北：臺灣學生書局，1966年），頁321。

專論

在此平面中。如此一來，風景既是人的製造，也製造人。風景不再是被人抽離自然本性的風景，而是在人與自然的相互關係中，視風景為人文自然的編造，編造不是幾種元素的簡單混合，而服膺於藝術家自身思索，以闡釋個性的選擇。對於環境的意識，且逐漸落實的繪畫創作，使作品具有不同於他人的魅力特徵。自然的面貌，經文人的汲取，將一種熱情的美學直覺轉化為一種超拔逸遠的韻致。

自有天地即有山水，山水的亙古存在，自有其自然之理。人類生存於天地之間，「參贊天地化育」成為人類道德的最高表現。時間的流逝意味著經驗的成熟，作為文人文化形式之一的山水畫，或因時代斷裂在自然觀、材質工具的選擇、練習的實踐和境界理想等方面有著待解決的難題，但是當自然美學的意念提煉於上之時，形塑永恆性的「真山水」，便較過往純概念化的「胸中丘壑」更為具體。正如〔山外步花〕，那是可行、可望、可居、可遊的風景，也是這塊土地蘊藏的美感。

對他而言，「做為一位出版人與藝術愛好者，不斷思索如何在藝術與生活之間取得一種和諧與平衡的關係。」是以人與自然之間，就是一種和諧與平衡的關係，而非單一方向的傾斜。回歸創作的本意，正是追求人與自然、人與人、人與自己的平衡，也就是從內在的真、善開啟發端，再一步步提昇到美的覺知。長時間的寫生經驗，呈現自己從自然習得的生命哲思，更讓他感受到自然的重要性，這讓畫作多了傳統水墨創作中少見、對人文關懷的特質。正如熊秉明先生評〔三探九九峰〕云：「寫峰巒湖海用自家之法，追客觀之實貌，不因襲古人舊規。」「展卷縱觀，氣勢開闊而逼察一木一鳥一草一石皆細膩可愛，亦巧亦拙，亦拙亦巧，悲憫眾生之心自見。」★11此次最重要的作品【返回自然之夢】巨幅連作，是畫家的生命經歷與對土地情懷的深入演繹。這些人物、山石、海洋、樹木、符號種種畫面構成俱是場景與故事的交疊，文字說明畫作的創作緣由，畫面交待儀式的文化意義，兩相呼應凸顯書畫互文的文化底蘊，也進一步將畫家心中對於土地的看法表露無遺。

個人深信藝術根植於自身生活的土壤，才能越發茁壯成長。今日藝術表現多元且具活性，自然仍是思考藝術靈感的來源，萬物造形依舊是學習的對象。只是人類不斷改造生活、改變環境，產生的遺憾也就不斷的蜂擁而至。當我們願意檢視過往的失誤，理解錯誤的代價，也許就能更加認識自然美學涵義，提醒自己珍惜土地的種種美好。

結語

美，因為多層元素而豐富，來自上天賦與、感官體驗、人文素養、文化積累以及開放態度與靜心回歸，讓美成為生活的一部分。內在自我與外在世界獲得平

★11——轉引自李賢文《人間清曠》
（臺北：雄獅美術，2012年），頁90。

衡，身心安適引來美感覺醒。體現於作品之上的諸多美好與感性，正是日積月累所陶冶出來的氣質，也是心靈對藝術美感的探索。

　　李賢文先生的繪畫作品，以寫生為基礎，用書法線條鉤繪形象，讓時空思維造境，畫面不求爭奇鬥豔的張揚，只有清曠淡雅的敘述觀察臺灣自然環境之變遷的想法。畫中所彰顯的意義，並非只是眼睛所看見的景致，更多的是企圖藉由繪畫的過程去陳述觀看時的感受，以及對理想的追求。從自然中所學習的不是企圖去征服自然或是改變自然，而是從中間得到生息的規則，體恤天地的循環，在俯仰之間感謝上蒼的關照。

初心重返 | 李賢文

有人把藝術視為心靈探險的歷程；有人在創作過程中，修練自性，安頓身心；有人則於遊戲歡喜間，展現創意。然而，對我而言，創作卻是一顆心的開始，周而復始。

喜歡自然，喜歡寫生，喜歡到大自然裡寫生畫畫，是我認識世界的啟端。在人群中的侷促，一到山林中，就變成自在與歡暢。早年因工作之故，有幸接觸許多與我一樣熱愛藝術的工作者，唯一不同的是，他們堅持創作，以生命沃養藝術的種籽，而我，卻在事業之版圖中，逐漸遺失自己曾有的初心。

這顆仰望藝術的心，卻始終不曾止息。五十之後，在重拾筆墨的瞬間，那橫亙於時空之海的二十五年歲月，無縫接軌，彷彿案上的筆，才剛放下，桌面的紙，餘溫猶存，攜帶畫具，走訪山林，變成尋訪初心的旅程。

從印度、拉達克、西藏、大陸，到回返島嶼，二十年來寫生創作之旅，充滿驚喜，當我開始用腳，真正走入林野，用手純樸描繪，用眼熱情觀看，用心細細品味，這個世界也以同樣的溫暖，深情回望。飽含山水之藏的臺灣，每一道山峰的稜線，每一條溪流的曲折，都像循循善誘的老師，引導著手中的筆，重新溫習線條、結構與肌理。而山海之間的雲霧晨昏，日出日落，又鼓舞著塵封的筆墨，向明暗、律動與色彩，尋找對應。我驚奇不已的發現，當我用藝術的眼睛看世界時，世界卻回我以文學的想像。

於是，寫生畫畫，變成無盡的回應與挑戰。當既有的技巧不足以描摩景物時，如何處理？面對紛雜的現場，如何揀擇標的？時空錯置的恍惚，如何表現？天地草木的荒涼，如何同理？沒有一本創作的百科全書，可以教導我們如何看，如何理解，如何對應，除了自己的那顆初心。

在仰視中部群山系列後，繼續描繪記寫九二一大地震，桃芝颱風中的流變悲歌。復於臺北塵寰中，堆疊古今，刻劃蜃樓，近年流連臺東海岸，開展出一系列海洋頌歌。尤其在蘭嶼，孤島上的絕色天地，激發出更昂然的創作能量，

遂有【返回自然之夢】系列聯作。從日出到月出，從綠野百合到岬岸羊群，從野銀部落到拼板舟，盛裝的髮舞與出海的勇士，簇擁著中間一幅蘭嶼組曲的核心作品，那是艾格里神父的蘭嶼頌，依舊迴響在現實與理想的波濤間，日夜不停。

在看得到的事物中，去超越既有的視覺感官與技術可能，而後達到另一個世界的開展，這是創作中最大的滿足，也將是未來努力的方向。尋找一顆心，就是尋找自己的歷程。從創作中，我終於理解，繪畫是我認識世界的啟端，也是了解自己的開始。

返回自然之夢——蘭嶼組曲

Dreaming Back to Nature — Orchid Island Suite

返回自然之夢——蘭嶼組曲

日出青青草原｜130×65.5cm

2016-2017｜虎皮宣・彩墨

Green Grassland at Sunrise
colored ink on tiger-skin textured xuan paper

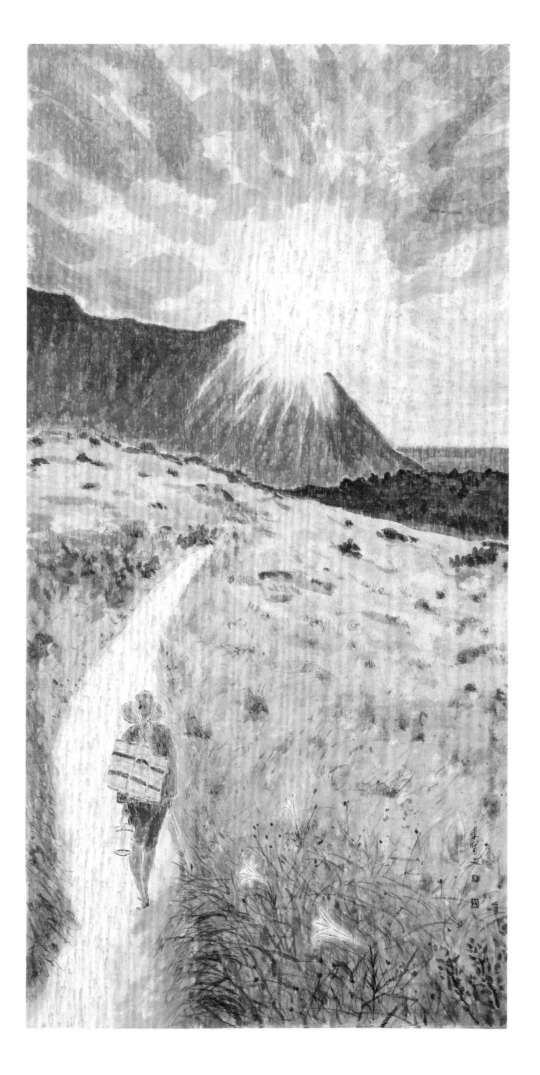

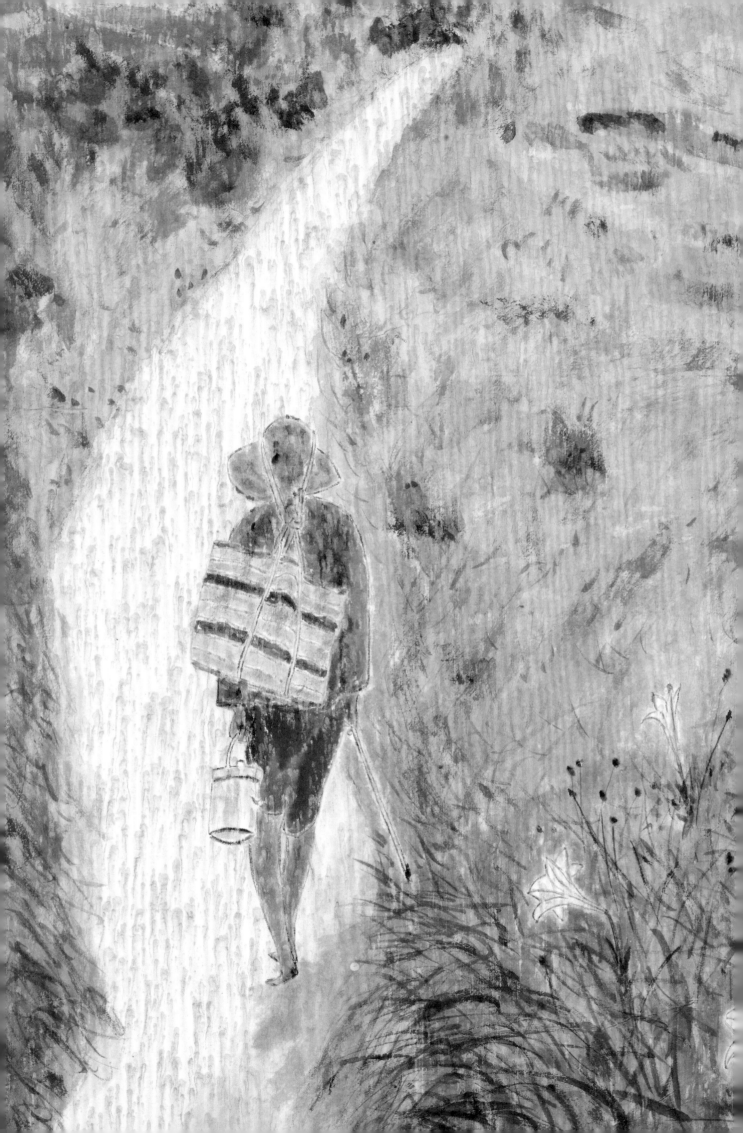

返回自然之夢——蘭嶼組曲｜日出青青草原＿局部

返回自然之夢——蘭嶼組曲

野銀部落｜130×65.5cm

2016-2017｜虎皮宣‧彩墨

| Ivalino Tribe
| colored ink on tiger-skin textured xuan paper

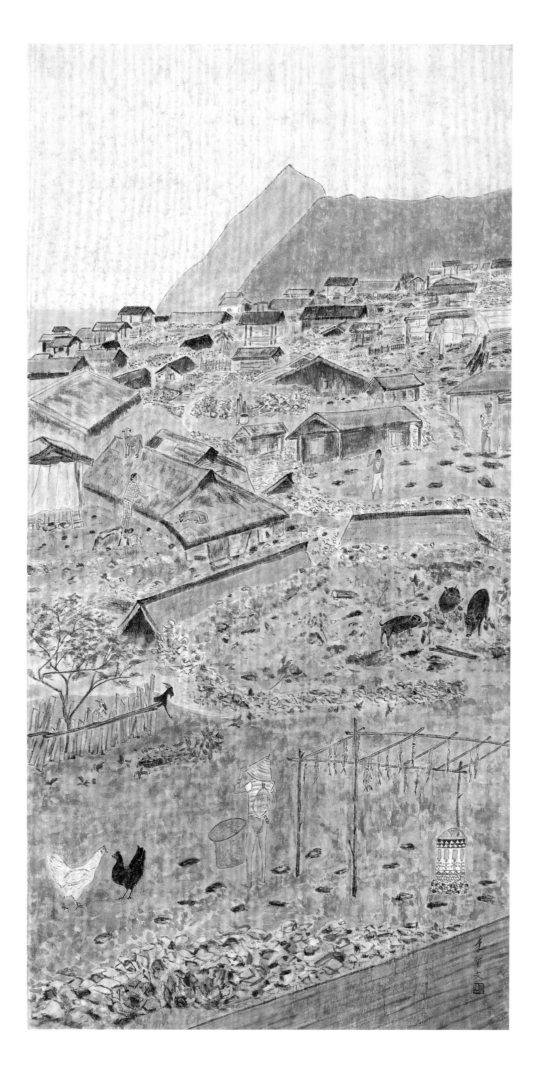

返回自然之夢——蘭嶼組曲

野銀部落_局部

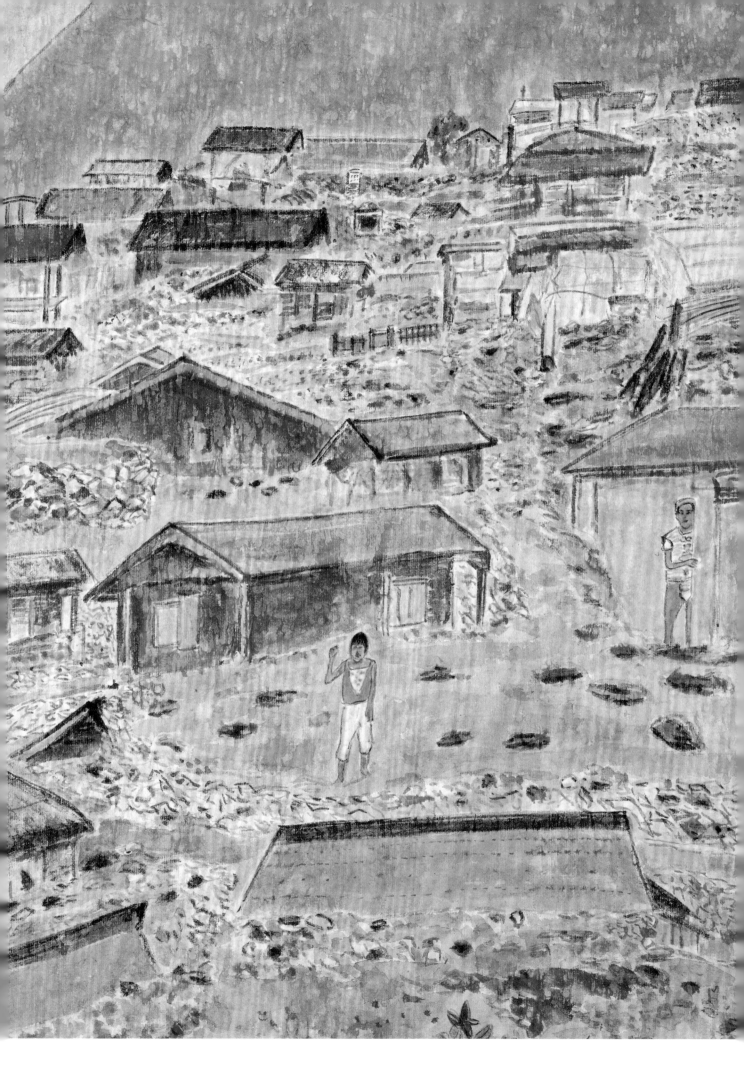

返回自然之夢——蘭嶼組曲

達悟勇士 | 130×65.5cm

2016-2017 | 虎皮宣・彩墨

| Tao Tribe Warrior
| colored ink on tiger-skin textured xuan paper

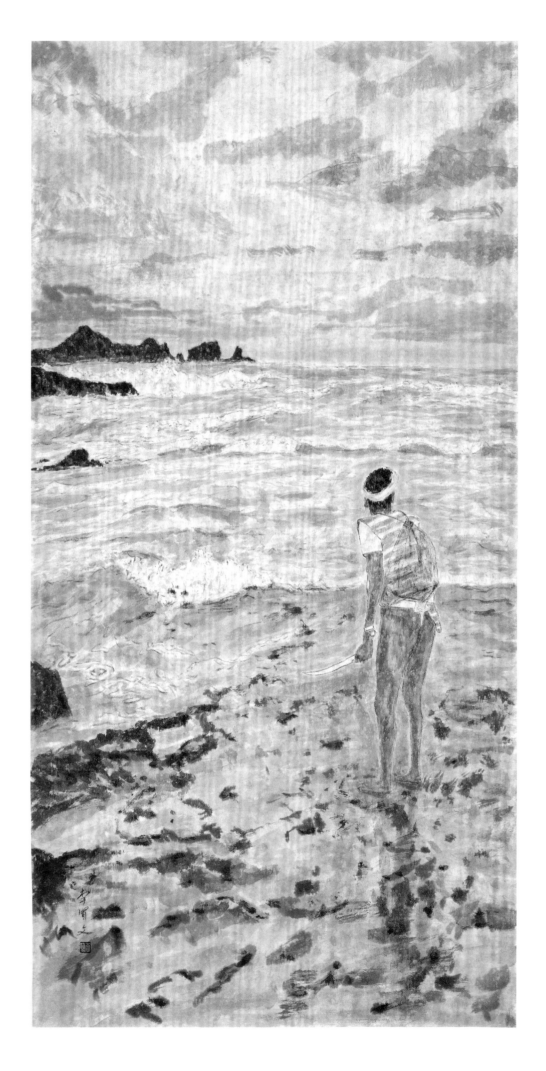

返回自然之夢——蘭嶼組曲｜達悟勇士_局部

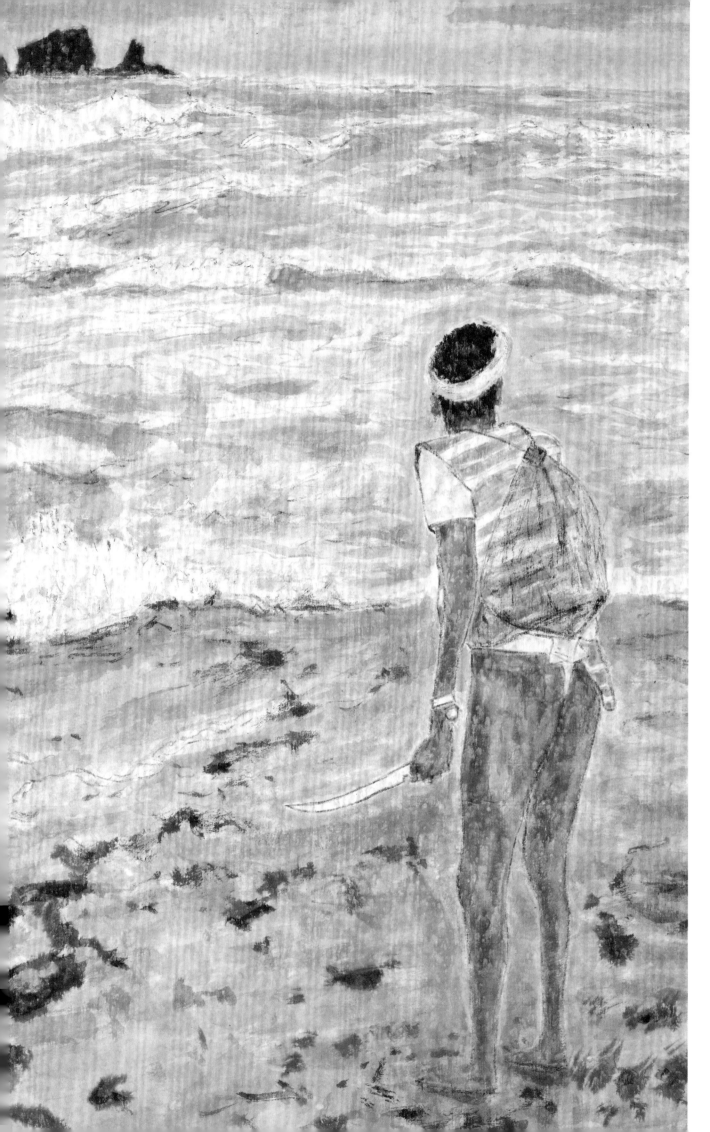

返回自然之夢——蘭嶼組曲

拼板舟│130×65.5cm

2016-2017│虎皮宣・彩墨

| Puzzle-Plate Boat（Tao：Tatala）
| colored ink on tiger-skin textured xuan paper

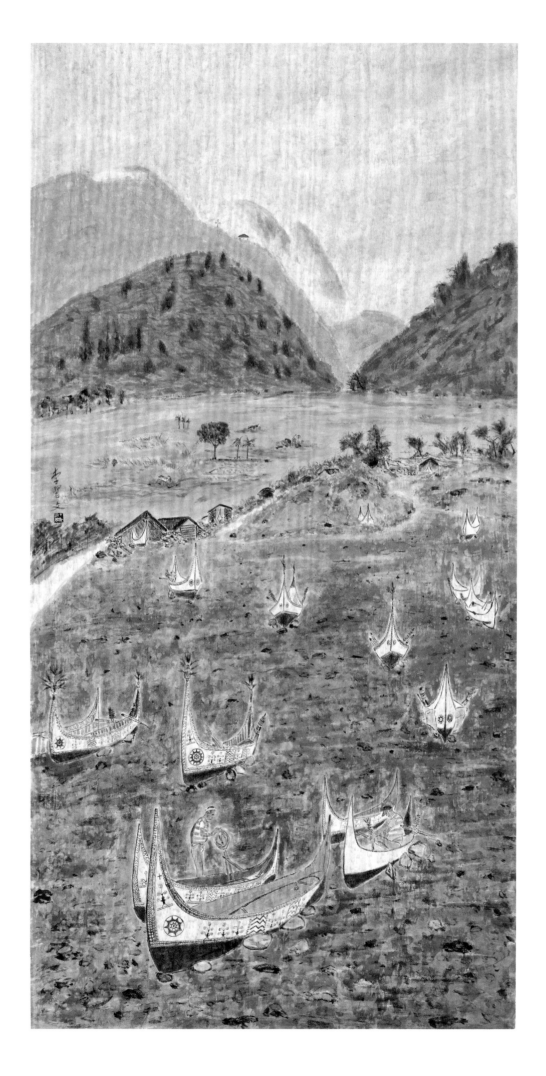

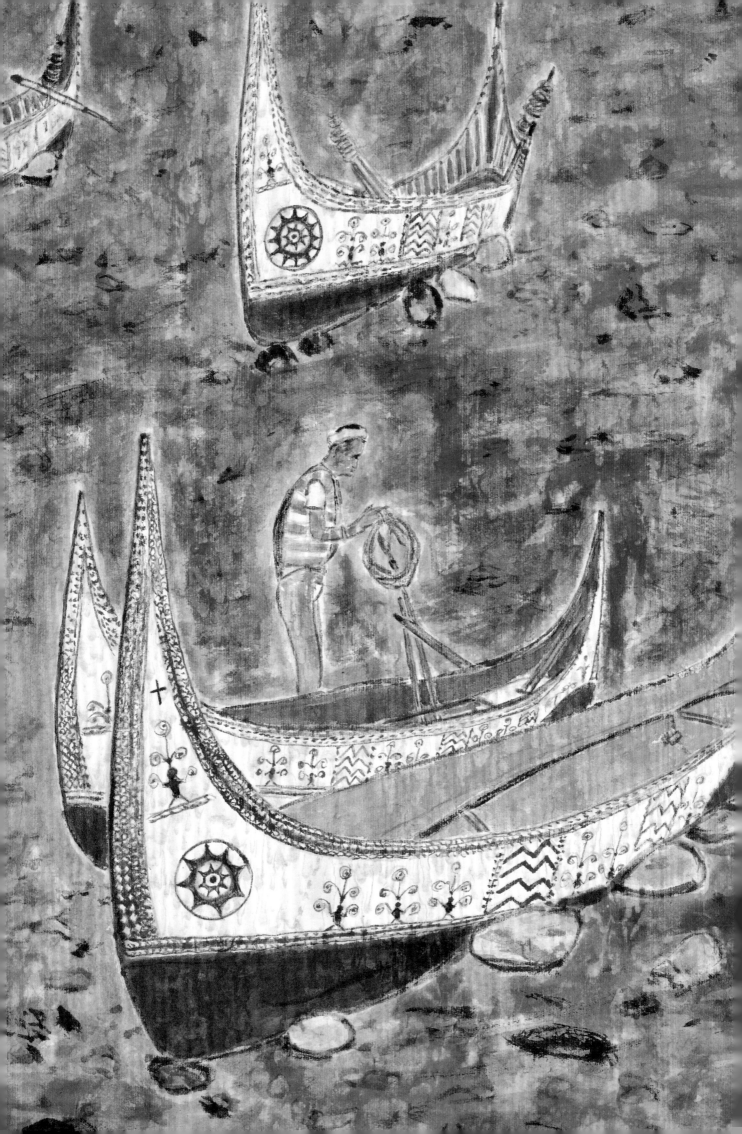

返回自然之夢——蘭嶼組曲｜拼板舟_局部

返回自然之夢——蘭嶼組曲

返回自然之夢 | 130 × 65.5cm

2016-2017 | 虎皮宣 · 彩墨

| Dreaming Back to Nature
| colored ink on tiger-skin textured xuan paper

上個世紀的六十年代，每年我總是慣於乘坐一艘小小的漁船造訪蘭嶼，我的原意只是想在不同的地方度過我的假期，多麼不可思議，這趟旅行把我拉進了時光的迴廊，回到我從來不敢想像的存在。旅程的多數時間裡必須橫越凶惡的海況才能抵達這座島嶼，而我也每每驚豔於這島上醉人的風景。有個幾近與世隔絶的古老文化聚落坐落在這裡。男性只穿著遮住下身的一塊布行走，嚴肅而堅毅的臉龐說明了自以前到現在生活上的艱辛。婦女則專注的照顧水芋田。男人則忙著漁撈，在黃昏出海直至隔天清晨回來，共同分配所得的漁獲，將捕來的魚用繩子串起來在屋子前晒乾作為嚴冬時節的存糧……現在時代改變了，島上建造了公路，車輪快速通行其上，擴音機高分貝的音量引誘著觀光客進入商店與旅館，打破了村莊裡原有的寧靜。日復一日，飛機和船隻載來了無數的旅客，侵入這原本遺世獨立的海上明珠。

於是我再也不曾踏上那座島，我害怕自己無法承受這樣巨大的轉變，然而，即使我對這座島的嚮往開始幻滅，但在我心裡那美麗的夢境將永遠存在。

節錄二〇〇五年艾格里神父之文

I used to travel to Lanyu (Orchid Island) on small fishing boats every year back in the 60s, with the intention of spending vacation times in a different setting. Incredibly, the journey pulled me into a corridor of time back to a state of being that I never dared to imagine. A large part of the journey included traversing through treacherous waters to reach the island, an island that enchanted me every single time with its mesmerizing landscapes. On the island were several settlements with ancient cultures that were almost completely isolated from the rest of the world. The men of the tribe walked around wearing only loincloths, with their serious and determined faces showing the hardship they had to endure living on the island from the ancient times till now. The women attended to the water taro fields, and the men took on the task of fishing, setting out to sea at dusk and did not return till the next morning. The catch was shared equally, with the fish preserved for harsh winter times by stringing on ropes to dry at the front of houses. However, times have changed. With expressways built on the island, vehicles are seen speeding by. Loud broadcasts are heard coming from shops and hotels hoping to lure in tourists, shattering the island's once peaceful quietness. Day after day, airplanes and boats usher in countless travelers, as they invade this what used to be a glistening pearl on the seas kept away from the rest of the world.

Thus, I never set foot on that island again, because I fear that I would not be able to handle the drastic changes. However, even though the longing that I've once had for the island is now crushed, the beautiful, ethereal land inside of me will forever remain.

Excerpt from Reverend Egli's essay written in 2005

返回自然之夢

上個世紀的六十年代
每年我愿是慣於來坐一艘小的漁船造訪蘭嶼
我的原意只是想在不同的地方度過我的假期
有時光週廢回到終点後不敢想像
多麼不可思議，這趟旅行紀我拉進
的奇在旅程的多數时間裡禪文領橫越
兇惡的海況才能抵達這座岛嶼
而我也每次驚訝於這座岛上所人的風景

有了驚訝與世隔絕的古老文化聚落生活在這裡
男性居民皆者遠住下身的一塊布行走
寂寞而堅毅的臉上说明了生活的艱辛
婦女們專住的照顧水芋田
男人則忙著漁撈
共同分配所得的溫飽
將捕來的漁用曬干串起來掛在屋子前
晒乾作為嚴冬时節的食糧

現在時代改變了岛上建造了公路車輛快速通行其上
擴音機高分貝的音響另湧著蕃光祭進入商店與旅館
打破了村莊和原有的寧靜
日後一日飛機和船隻載來了無數的旅客湧入這原本
遺世獨立的海上明珠

從這我再也不曾踏上那座岛
我害怕自己
無法承受這樣巨大的轉變
然而
即使我對這座岛的嚮往
劇烈的減
但在我心裡那美麗的夢境將永遠存在

寫繪於二◯一五年艾格里神父去世
李賢文 二◯一七丁酉春

約古一九七六年成功嶺持到台東雅美附分利社
高東行神父地拍攝的大量幻燈片並親以其資料海報了蘭嶼專輯
並於一九六七年雜誌以神父從美原住民典本報紙市的稻穗
祥以附蘭嶼雅美文物集建城成文物草藝山傳愛

返回自然之夢——蘭嶼組曲
返回自然之夢_局部

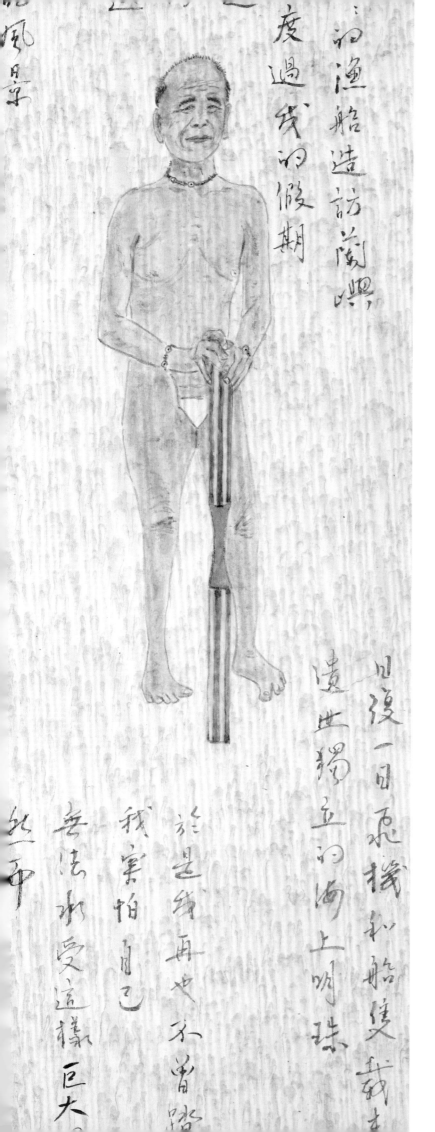

【後記】

約在一九七六年歲末，我接到臺東一位陌生人電話，不久這位艾格里神父來臺北雄獅美術月刊社，展示了他親攝的大量蘭嶼照片，翌年五月，雄獅以其資料編製了蘭嶼專輯。艾格里神父除以相機記錄雅美文化也編撰排灣族字典，奉獻臺東二十多年。二〇一三年病逝，享壽八十四歲。

謹以九幅蘭嶼組畫，感念艾格里神父的後山傳愛。

李賢文畫於二〇一六年丙申春，題於二〇一七丁酉春。

Postscript:

Around the end of the year in 1976, I received a phone call from a stranger in Taitung, and soon after that, Rev. Egli was in Taipei at the office of Lion Art Monthly with a lot of photographs of Orchid Island taken personally by him. In May of the following year, Lion Art produced a Lanyu monograph based on the materials he had provided. Besides taking photographs to document the culture of the Yami (Tao) Tribe, Rev. Egli also compiled a Paiwan Tribe dictionary. He had dedicated over two decades of his life to Taitung and passed away in 2013 at the age of 84. This 9-piece Orchid Island painting collection is a tribute to Rev. Egli's loving legacy.

Painted by Lee Shien-Wen in spring of 2016 and inscribed in spring of 2017.

返回自然之夢——蘭嶼組曲

羊角扶搖上 │ 130×65.5cm

2016-2017 │ 虎皮宣·彩墨

│ Goat Horns Moving Upwards
│ colored ink on tiger-skin textured xuan paper

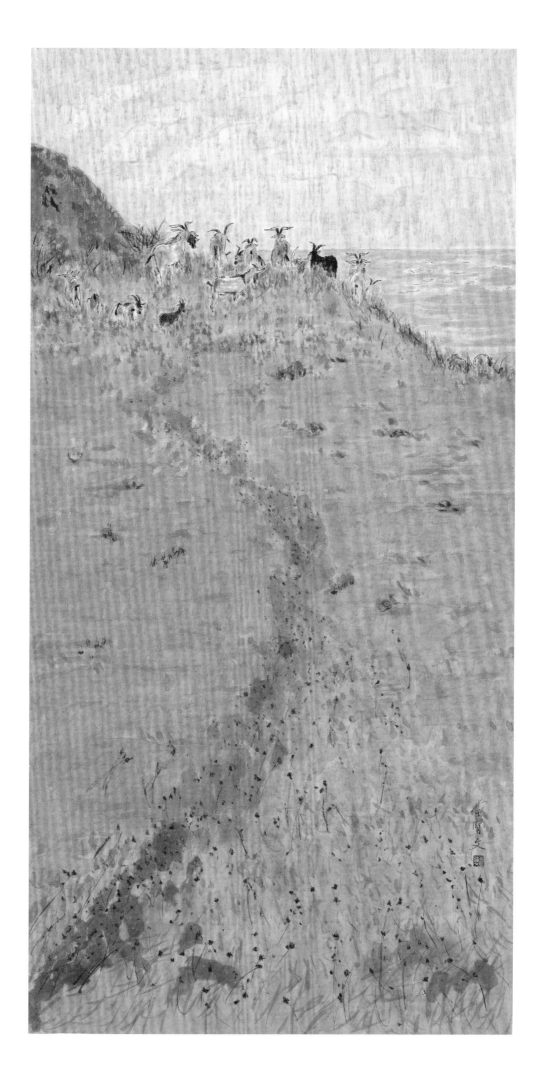

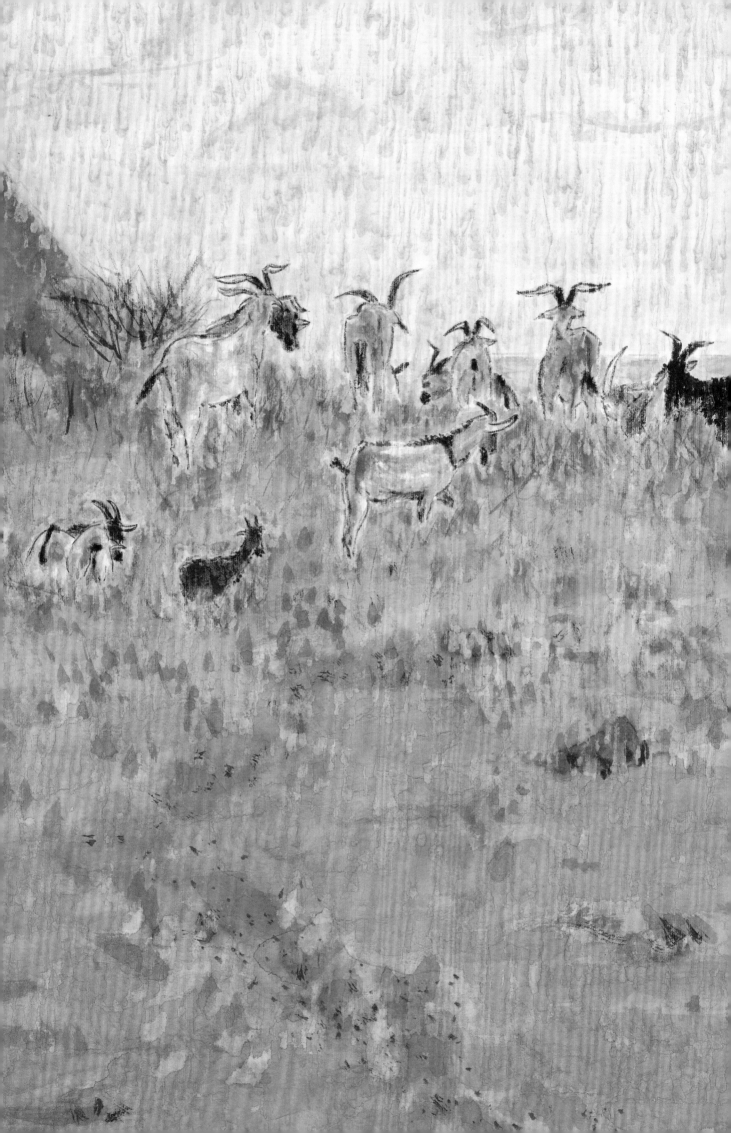

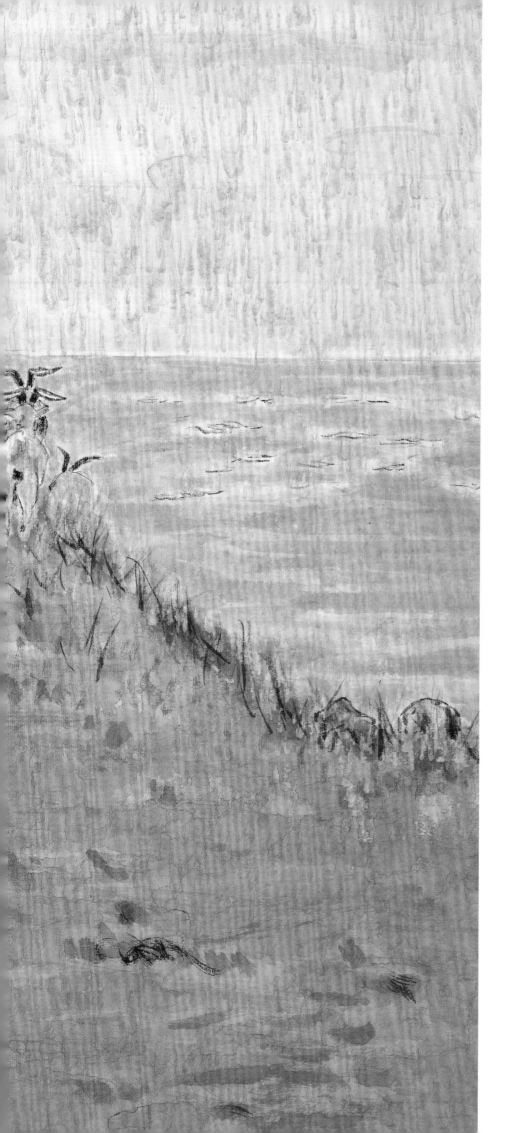

返回自然之夢

返回自然之夢——蘭嶼組曲

羊角扶搖上_局部

返回自然之夢——蘭嶼組曲

野百合 | 130×65.5cm

2016-2017 | 虎皮宣・彩墨

| Wild Lilies
| colored ink on tiger-skin textured xuan paper

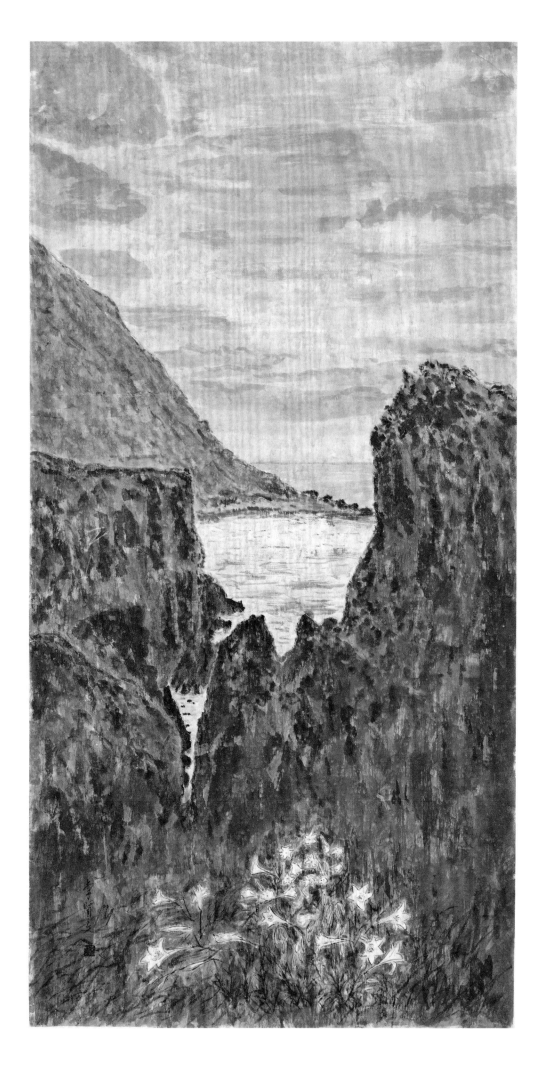

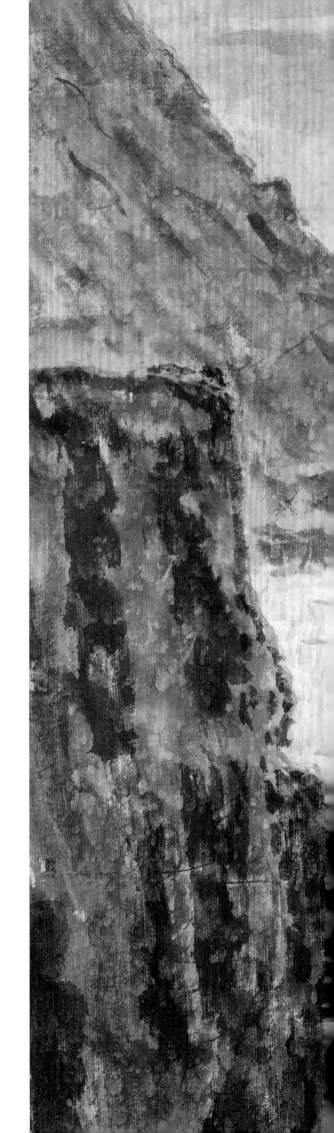

返回自然之夢──蘭嶼組曲│野百合_局部

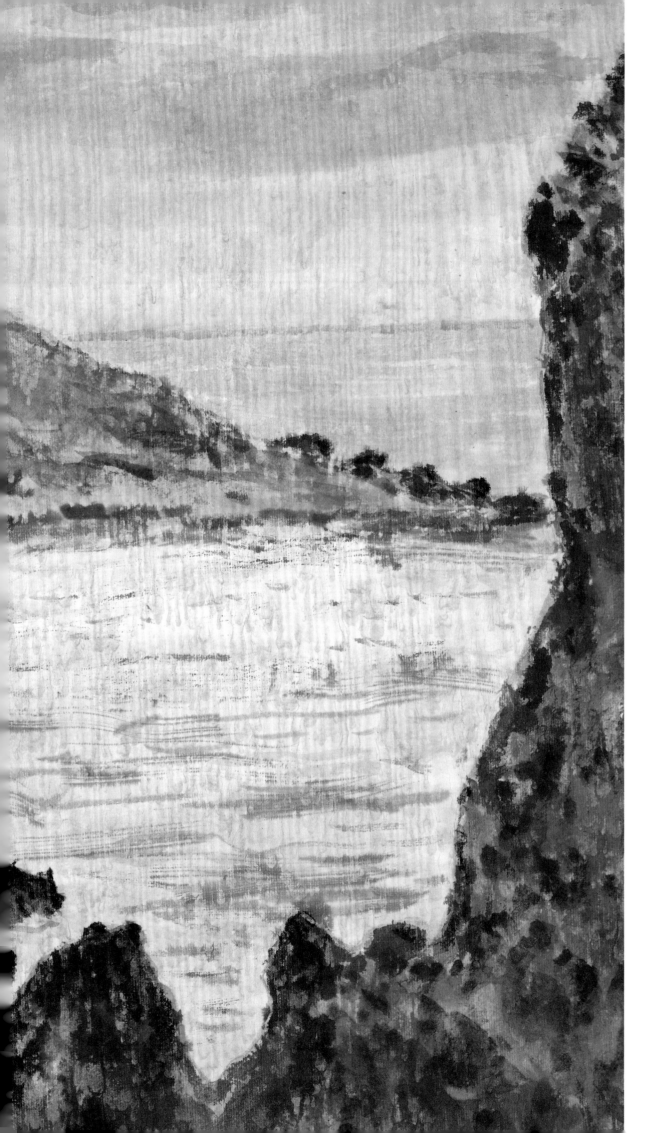

返回自然之夢——蘭嶼組曲

水芋田｜130×65.5cm

2016-2017｜虎皮宣・彩墨

Water Taro Field
colored ink on tiger-skin textured xuan paper

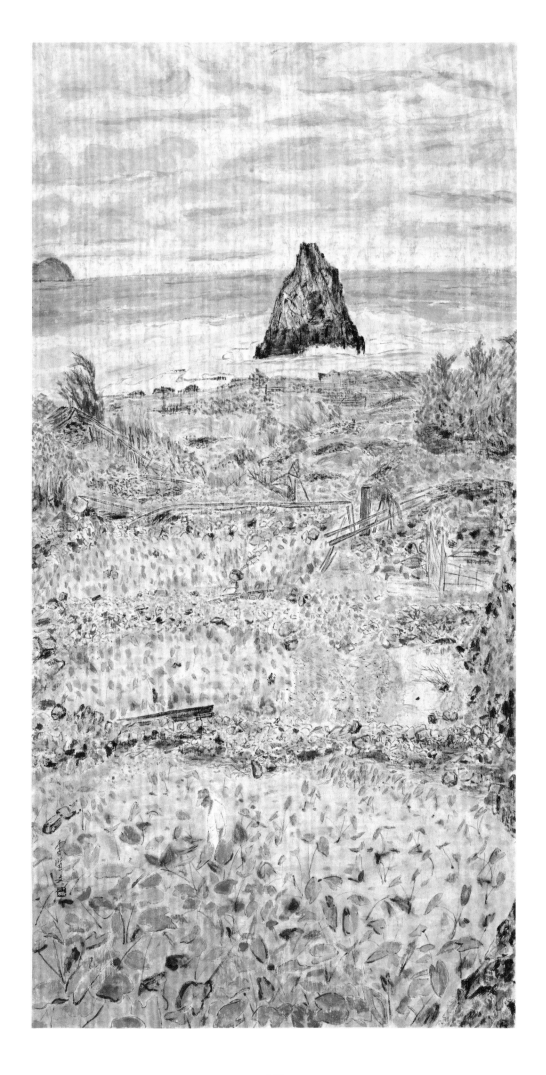

返回自然之夢

返回自然之夢——蘭嶼組曲│水芋田_局部

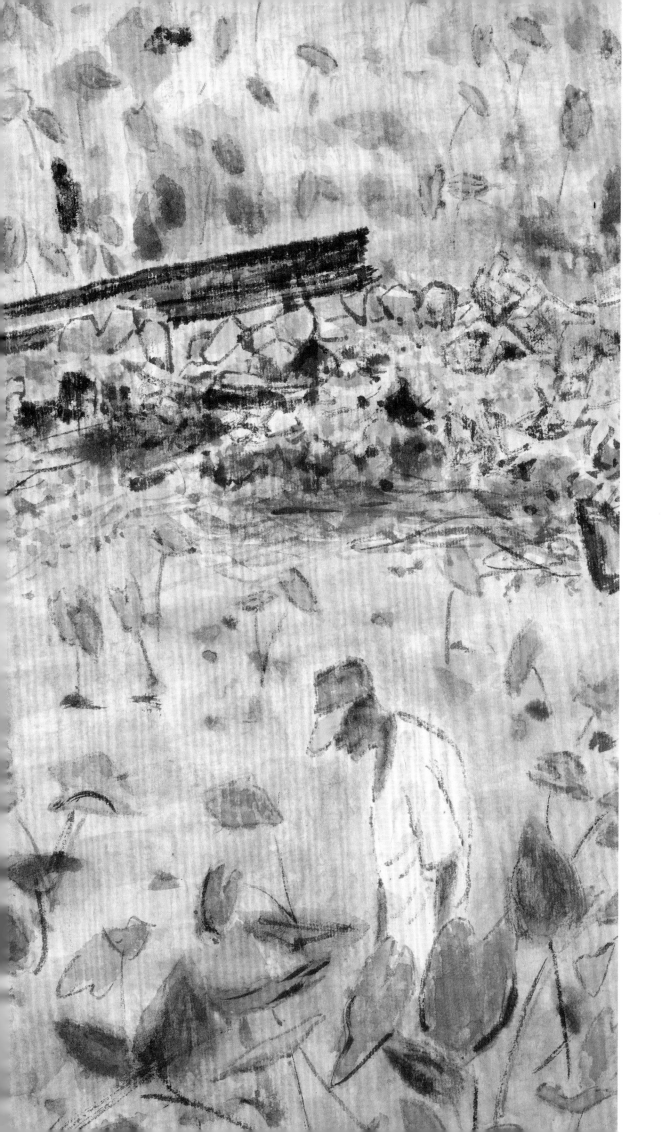

返回自然之夢──蘭嶼組曲

月下髮舞 | 130×65.5cm

2016-2017 | 虎皮宣·彩墨

| Hair Dance Under the Moon
| colored ink on tiger-skin textured xuan paper

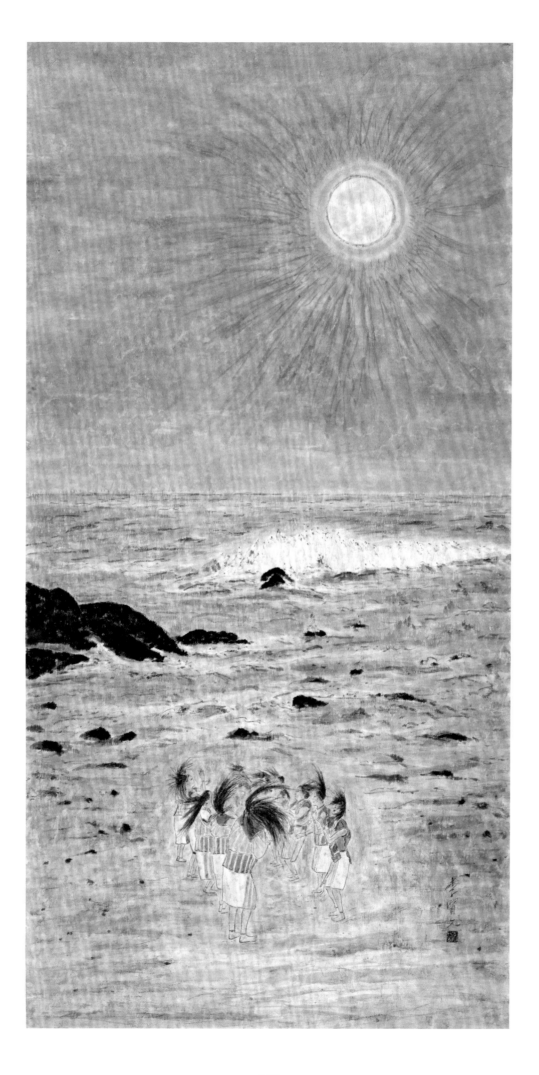

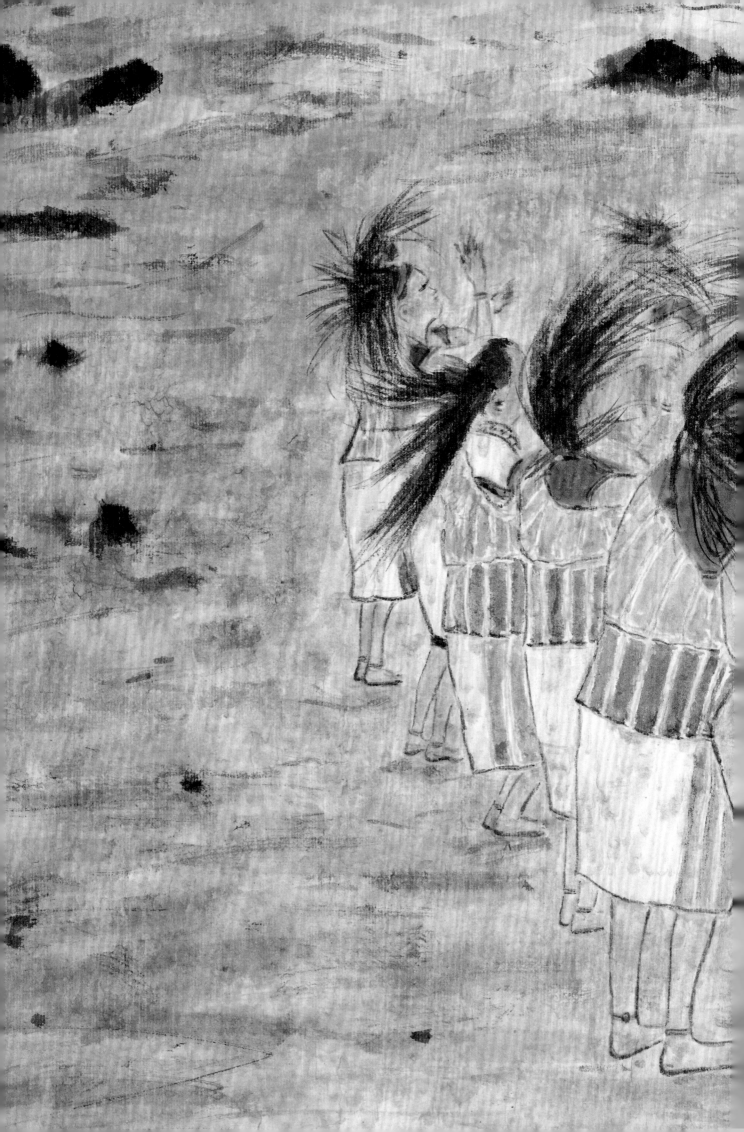

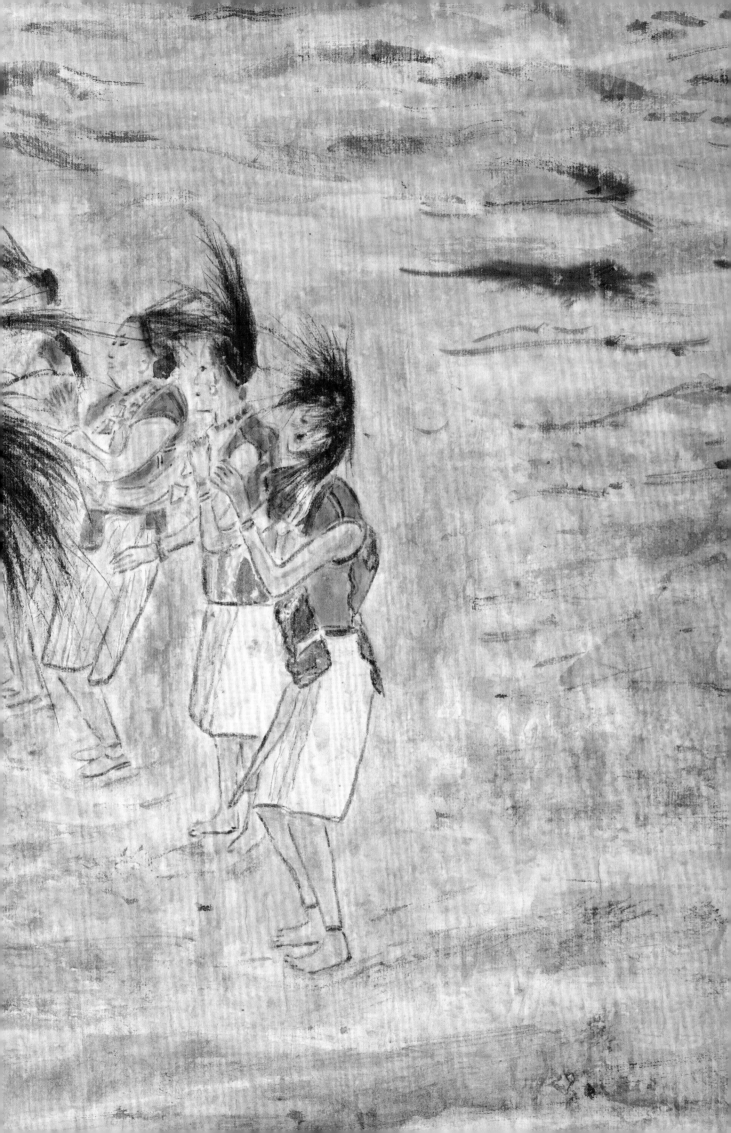

守護｜137×70cm

2016｜宣紙・彩墨

| Protection
| colored ink on xuan paper

【釋文】

哈古是卑南族頭目，也是著名雕刻家。民國八十一年，他為家鄉臺東
射馬干部落的祖先廟雕刻三尊神像，中間坐者，長髯束髻，貌似土地
公；右側為祭司，左邊則是勇士。三尊木雕代表部落禮敬天地，重視
傳承的核心價值。我把祖先廟中的三尊木雕凌空躍出，置放在真正孕
育卑南族人心靈的山河大地中，還原木雕神像守護子民的原始本心。
畫中三尊木雕如山湧立，站在山脈交界與河流的盡頭，是山的開始、
水的源頭，更是部落生命的啟端與歸處。

兩千十六年大暑　李賢文畫並題

Hagu is a Puyuma tribal chief and a renowned sculptor. He carved
three holy statues in 1992 for his hometown, Kasavakan Tribal
Village in Taitung. The statue in the middle appears like the Lord of
the Soil and the Ground with long beard and hair in a topknot. The
statue on the right is a shaman, and the one on the left is a warrior.
The three wooden statues represent the tribe's core values that place
emphasis on respecting nature and heritage. I've levitated the three
wooden statutes from their ancestral shrine and positioned them in
the midst of a grand natural landscape where the spirits and souls
of the Puyuma tribal people are nourished. The gesture is to bring
the wooden holy statues back to their original purpose, which is
to protect the people. The three statues are depicted like towering
mountains and are positioned at the crossing points of mountains
and at the end of where the river flows. The origin of mountains and
water is where the vitality of the tribe begins and belongs.

Painted and inscribed by Lee Shien-Wen in 2016.

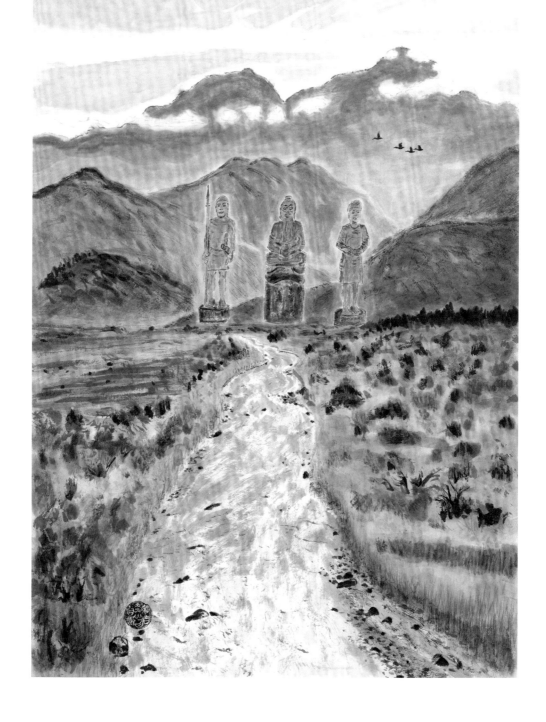

守護

哈古是卑南族頭目也是善於雕刻家
國八十一年他為家鄉
台東射馬干部落的
祖先廟雕刻三尊神像
中間坐者舜東蓉敏似土地公
古倒為祭師台遷則是高大
三尊木雕
...

三十十六年　大暑
李賢文畫并記

後山傳愛｜137×70cm

2016｜宣紙・彩墨

Legacy of Love Behind the Mountains
colored ink on xuan paper

【釋文】

走訪東海岸，遍歷山海，最使我難以忘懷的是，那隱藏在荒野山區，僻陋村落裡，一座又一座微小卻昂然樹立的教堂，點燃出早期西方教會在臺灣僻鄉的不滅之愛以及後山傳奇。隸屬於瑞士白冷會的東河天主堂，就是其中之一。一九六四年來自瑞士的蘇德豐神父（1929-1989）為當時新建的東河天主堂繪製了耶穌復活的壁畫，以對開的形式，畫在祭壇背面主壁上。右圖畫耶穌跪地向象徵上帝的太陽合十禱告；左圖則是耶穌正面直立，雙掌雙足，流出鮮紅血液，宣告復活。

當我仰望這件色彩活潑，造型現代的作品，內心更為感動的卻是故事之外，背後創作者澎湃的才華與異域傳教的人生。為了表達對蘇德豐神父以及許許多多，遠渡重洋來臺宣教服務的神職人士之敬意，遂以臺東海岸，日出海面為背景，將東河天主堂壁畫，鑲嵌在初昇旭日的兩端。兩幅壁畫，左右合拱，仿如聖頁開啟，天降福音。畫中之日與景中之日，此時合圍成一圓，自然之輝與人性之光，同臻聖境。

兩千十六丙申年春　李賢文畫並題

The most memorable part from my travels through the mountains and sea in Taiwan's East Coast are those small but proudly standing churches hidden in the mountainous regions, inside humble villages. They stand as witness of the undying love and the legacy brought over in the early years by the Western church to those remote Taiwanese townships behind the mountains. Donghe Catholic Church is a sector of the Swiss Bethlehem Mission Society. Fr. Gottfried Suter (1929-1989) of Switzerland painted in 1964 a mural of Jesus's resurrection in the then newly constructed church, with the image depicted in a two-fold style on the center wall behind the altar. On the right is an image of Jesus praying to the Sun, a symbol of God. On the left is an image that represents resurrection, with an image of Jesus standing upright with blood oozing from his hands and feet.

When looking up at this vivid and modern artwork, my heart is filled with moved emotions evoked not by what is depicted but the life of the tremendously talented foreign missionary behind the artwork. I've created this painting as homage to Fr. Gottfried Suter and the many other missionary workers that have traveled long distances to Taiwan. Depicted in the background is the coast of Taitung at sunrise, with the mural from the Donghe Catholic Church embedded at the two ends of this rising sun. The silver gray highway is depicted heading towards the giant sun with three dazzling golden rays. The two murals are juxtaposed side-by-side, appearing like an opened Bible sending blessings from up above. The suns in the murals have become one with the sun in the background of the painting, with nature's light and humanity's light joined together forming a sacred world.

Painted and inscribed by Lee Shien-Wen in spring of 2016.

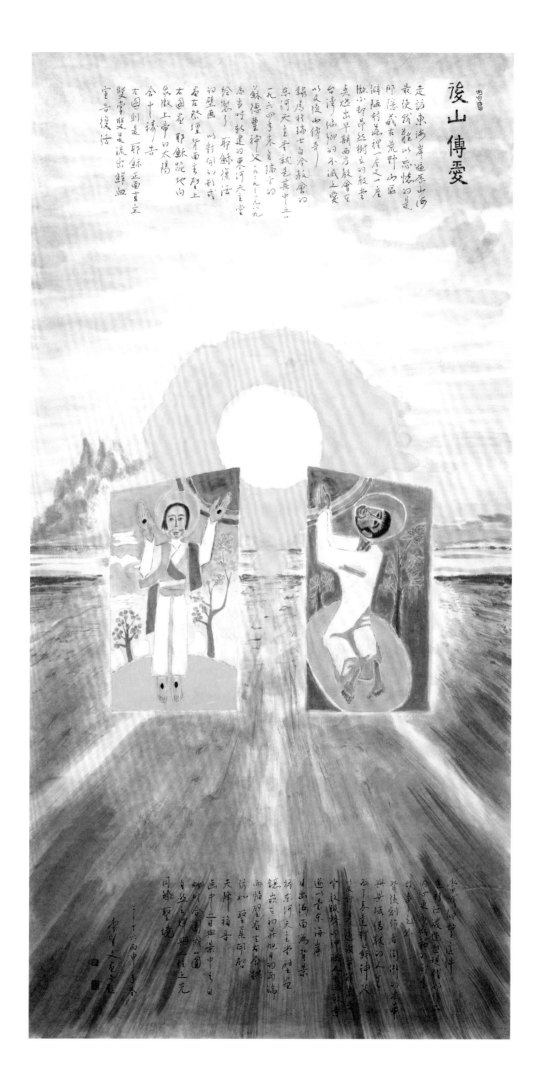

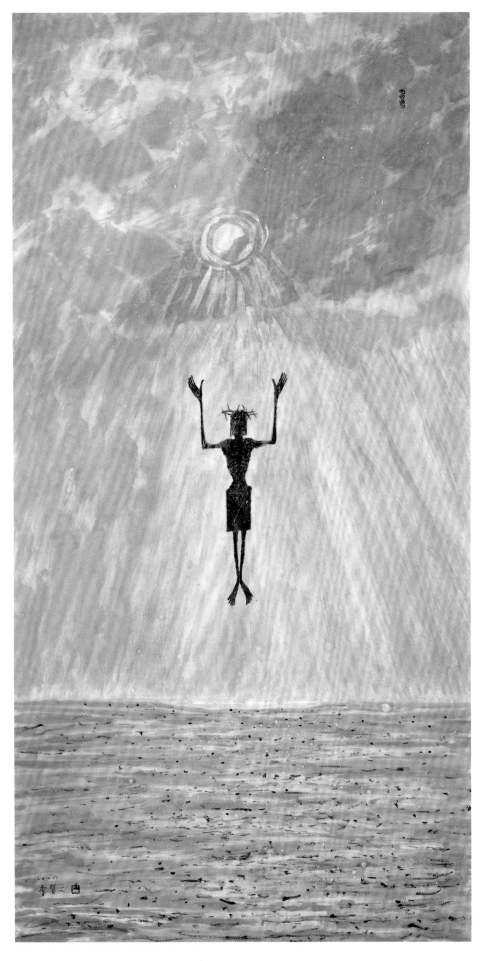

復活｜137×70cm｜2016｜宣紙・彩墨 ｜ Resurrection｜colored ink on xuan paper

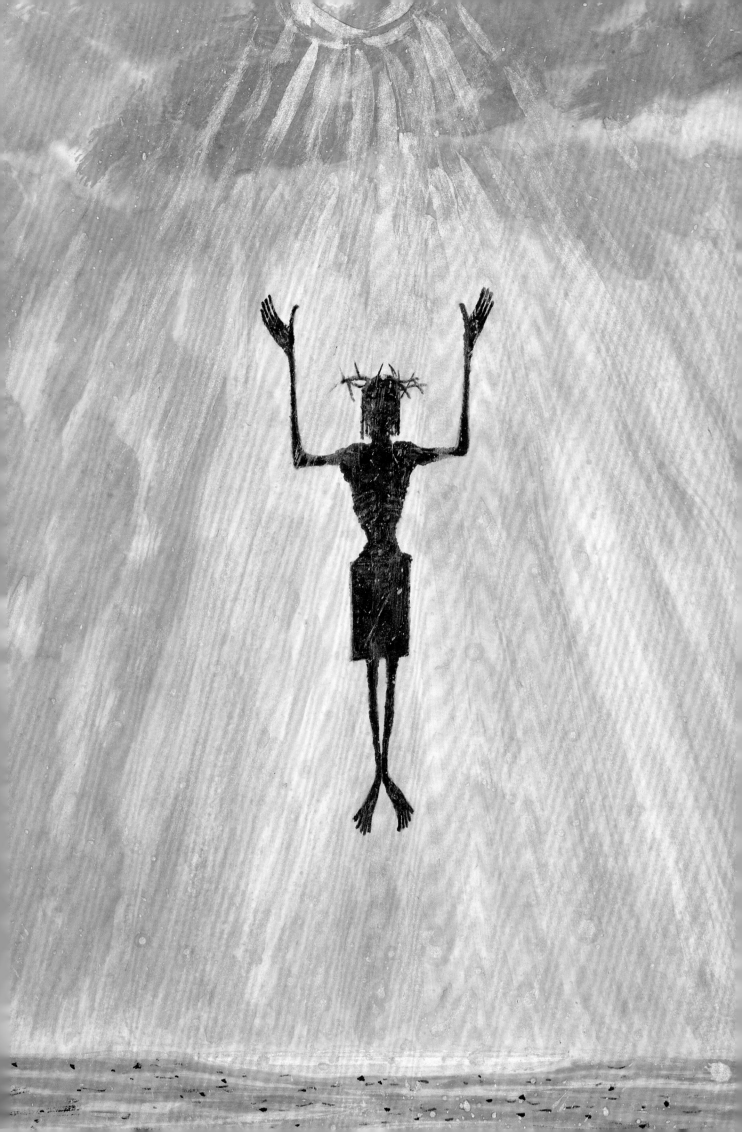

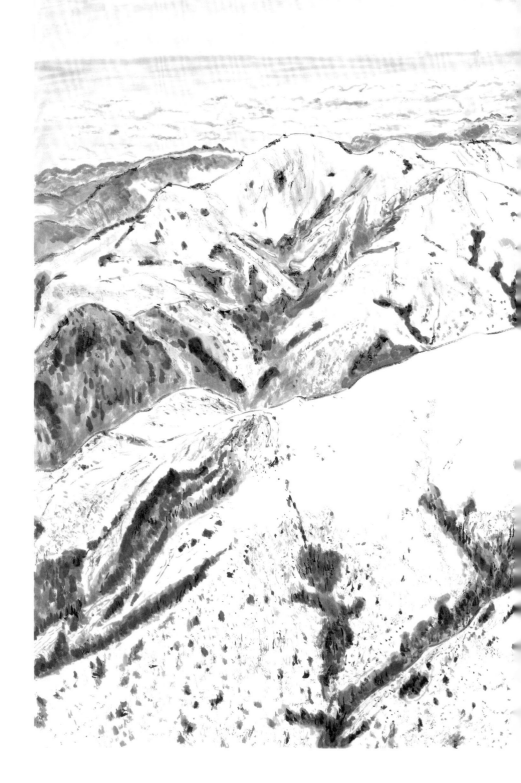

積玉連山 ｜ 100×160cm

2015 ｜ 宣紙・彩墨

Accumulated Treasures on
Continuous Hills
colored ink on xuan paper

勤接力筆隨意臨競風華我欲振衣高崗上水墨開出自然魂 立鼇峯在千里外連山積玉玉山峰
二柳英山河壯闊派詳綿延 遂畫積玉連山圖以誌慕 李賢文 畫并題 二千十五年十月

【釋文】

千年范寬萬丈山，擎天巨嶂立典章，歷代名士勤接力，
筆隨意臨競風華，我欲振衣高崗上，水墨開出自然魂，
丘壑豈在千里外，連山積玉玉山峰。

今年夏秋之交觀臺北故宮九十年范寬及其傳派特展，
仰其山河壯闊，流輝綿延，遂畫積玉連山圖以誌慕。

李賢文畫並題　兩千十五年十月

A thousand years of Fan Kuan, a mountain of lofty heights. Iconic standards defined with emerald screen-like peaks holding up the skies with might. Courageous warriors through the years one after another up the soaring cliff. With my brush I evoke its grandeur. As I stand with my shirt fluttering up on the towering hill. With soul of nature drawn out by ink and water. Mountains and creeks not far in the distance. Treasures accumulate on the continuous hills.

Painted after seeing the exhibition, Exemplar of Heritage: Fan Kuan and His Influence in Chinese Painting, celebrating Taipei's National Palace Museum's 90th anniversary; Accumulated Treasures on Continuous Hills is inspired by the master's majestic, continuous, extensive landscapes.

Painted and inscribed by Lee Shien-Wen in October of 2015.

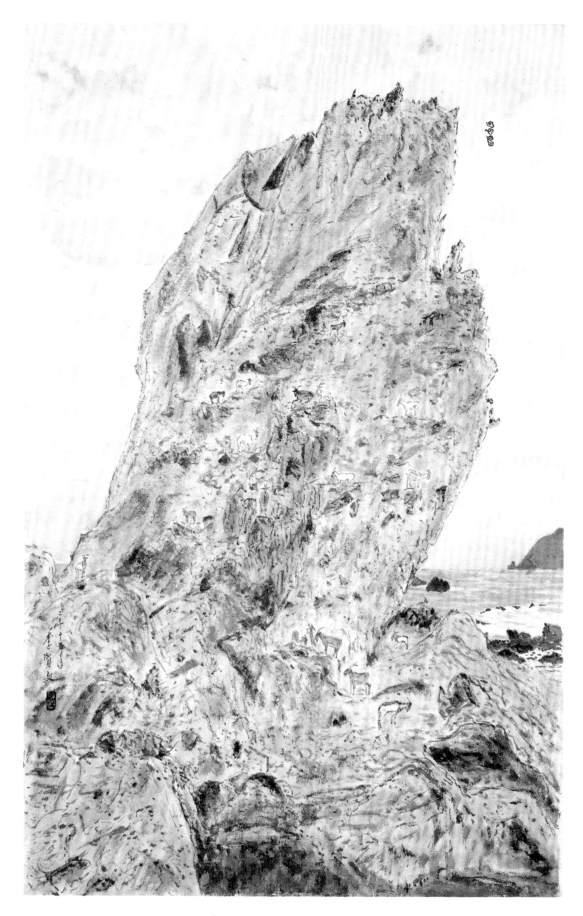

舞台 | 99×63cm | 2015 | 日本紙・彩墨 | Stage | colored ink on Japanese paper

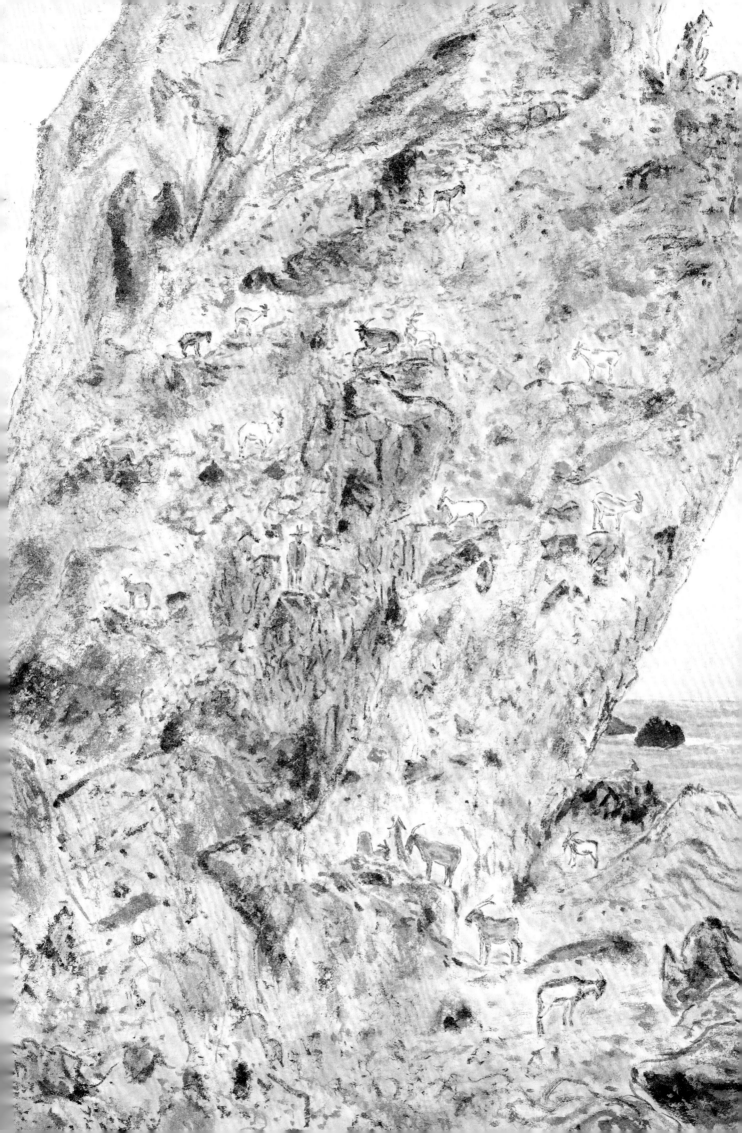

海上飛虹｜63×99cm

2015｜日本紙・彩墨

Rainbow Over the Sea
colored ink on Japanese paper

返回自然之夢

063

白浪吟｜63×99cm

2015｜日本紙・彩墨

Chants of the White Waves
colored ink on Japanese paper

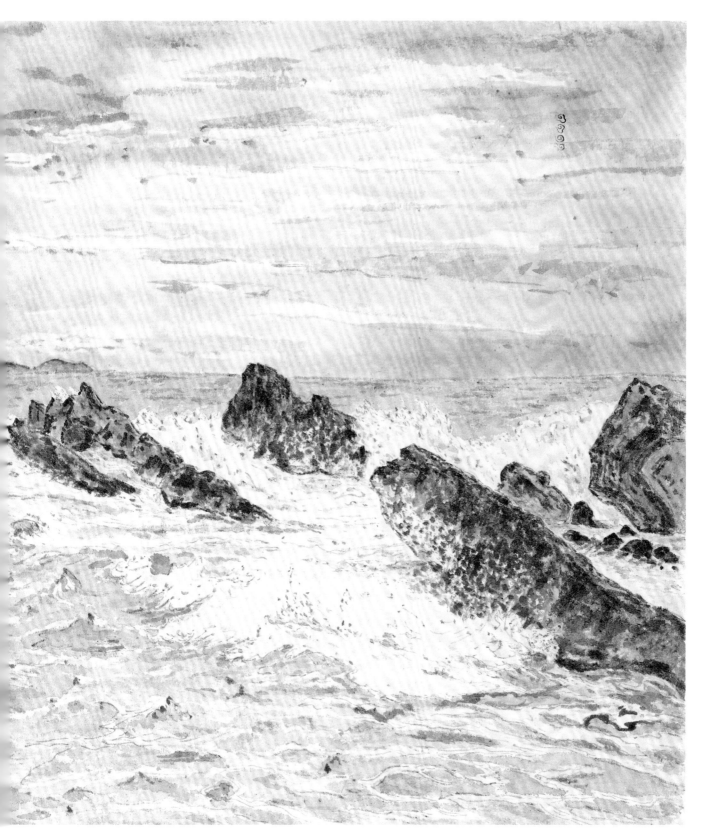

返回自然之夢

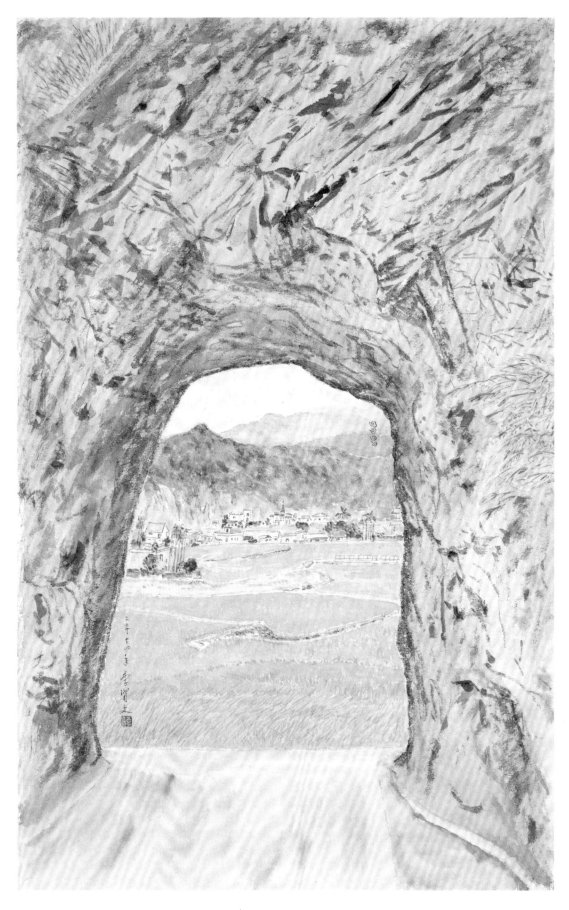

後山桃花源 | 99×63cm | 2014 | 日本紙・彩墨 | Paradise Behind the Mountains | colored ink on Japanese paper

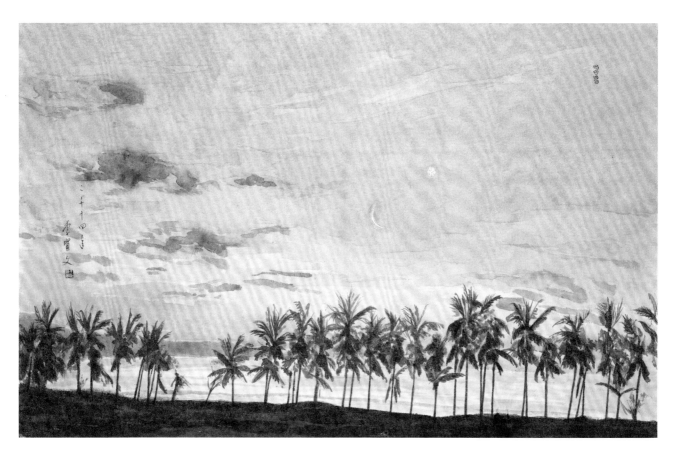

椰子海岸 | 63×99cm

2014 | 日本紙・彩墨

Coconut Coast
colored ink on Japanese paper

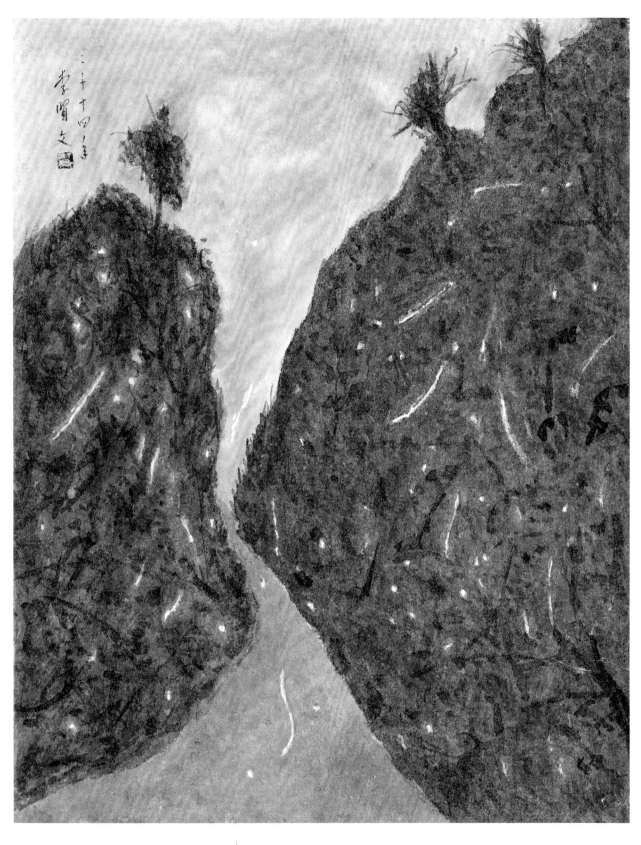

螢光如織 ︱ 63.5×50cm ︱ 2014 ︱ 日本紙・彩墨　　Entwining Glistening Lights ︱ colored ink on Japanese paper

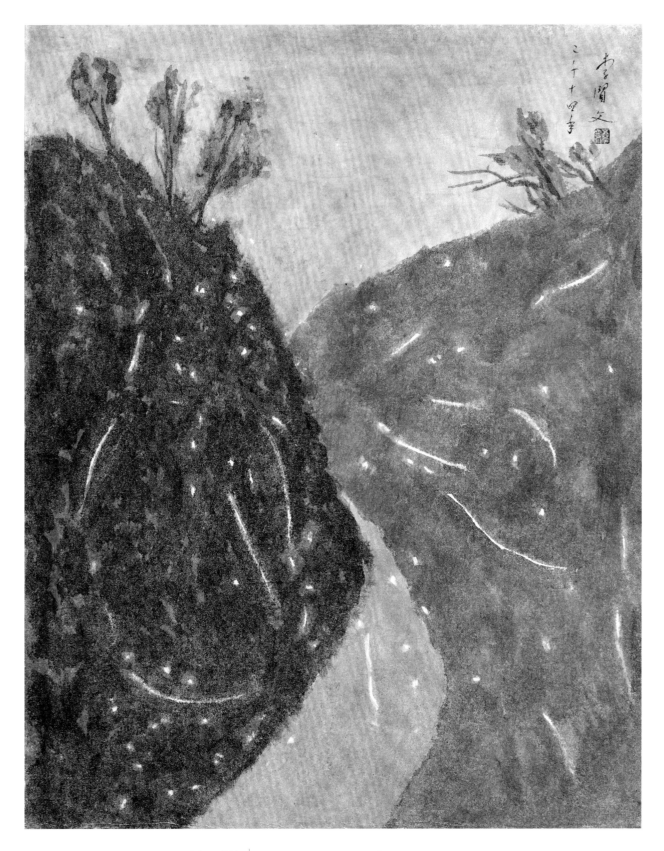

螢光如流｜63.5×50cm｜2014｜日本紙・彩墨　｜　Flowing Glistening Lights｜colored ink on Japanese paper

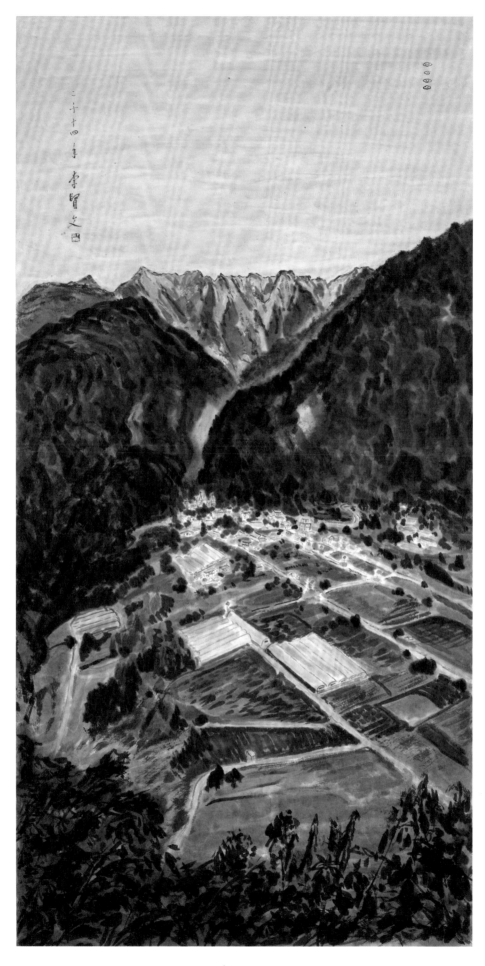

利稻曙色 ｜ 137×70cm ｜ 2014 ｜ 宣紙・彩墨 ｜ Lidao Tribe at Dawn ｜ colored ink on xuan paper

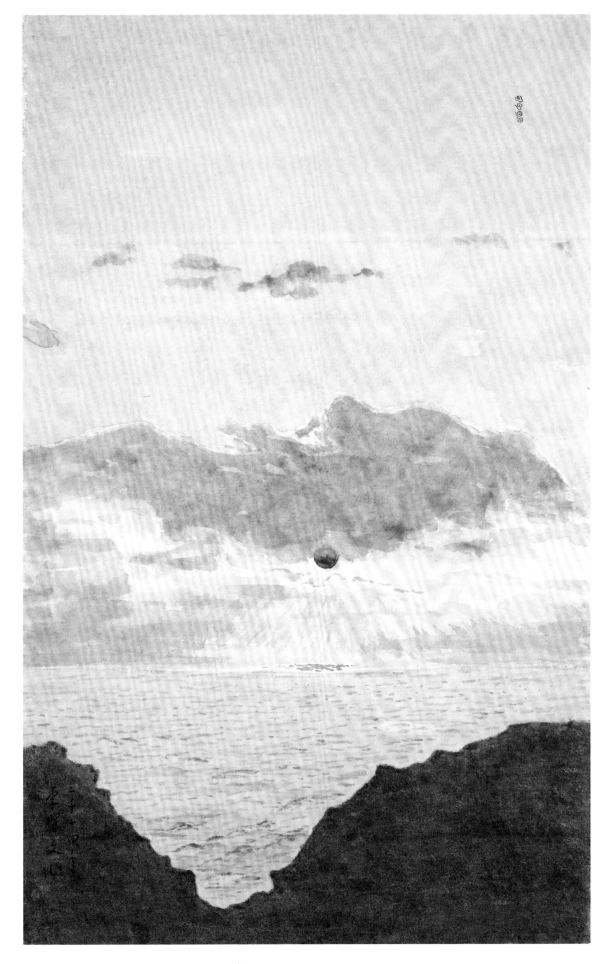

雲開日麗｜99×63cm｜2014｜日本紙・彩墨　｜Sun Shining Through the Clouds｜colored ink on Japanese paper

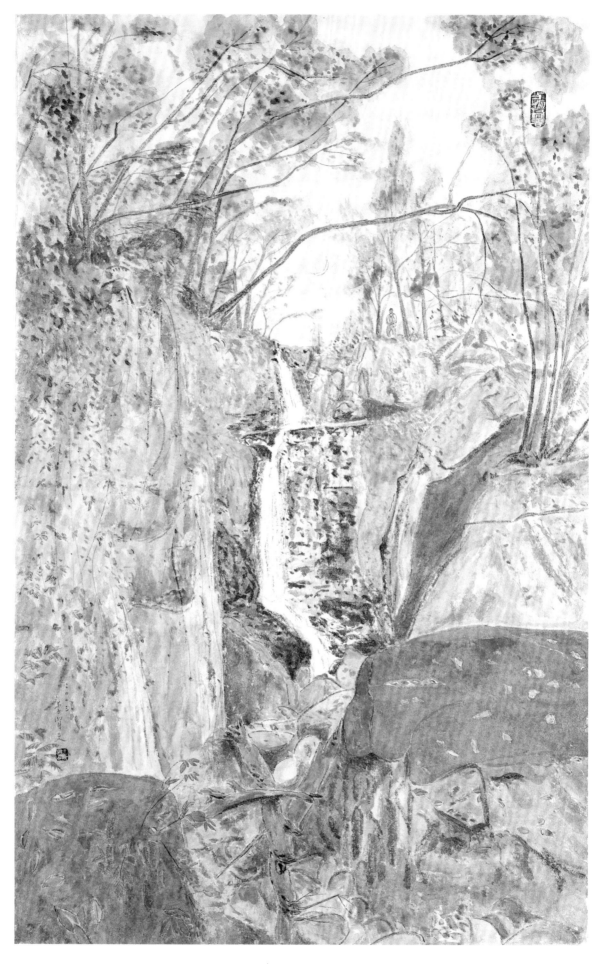

泉自奔忙月自遲 | 99 × 62.5 cm | 2013 | 日本紙・彩墨　│　Calm Amid Disarray | colored ink on Japanese paper

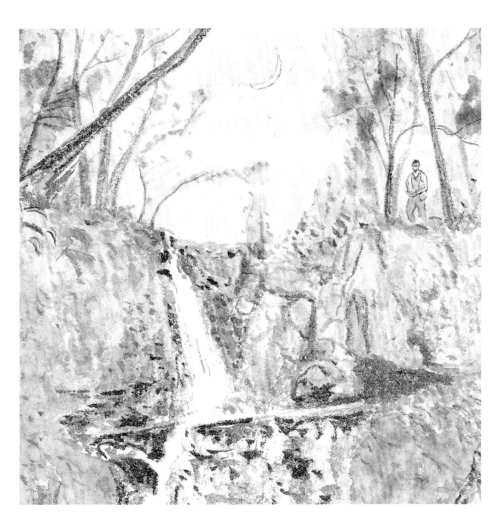

泉自奔忙月自遲_局部

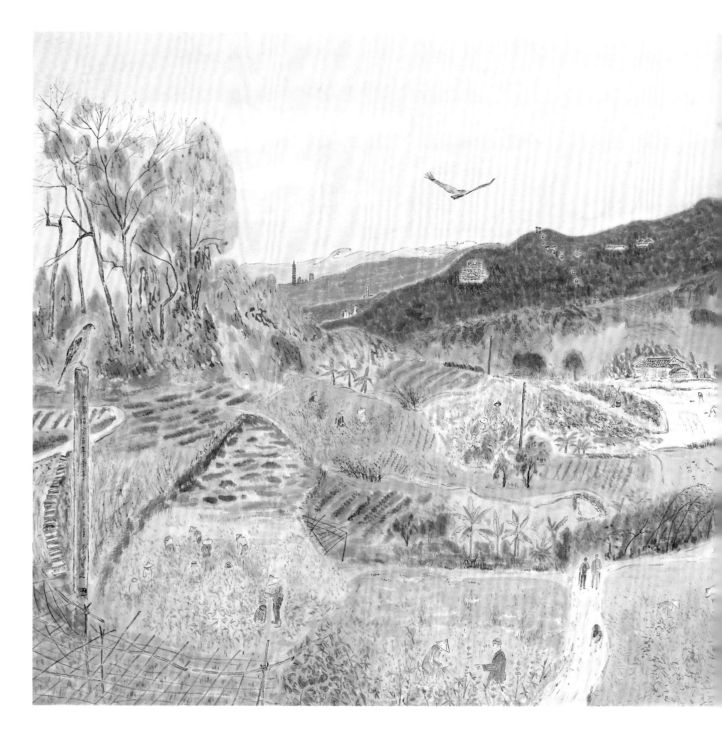

貓空百年茶事｜105×231cm

2013｜宣紙・彩墨

A Hundred Years of Tea in Maokong
colored ink on xuan paper

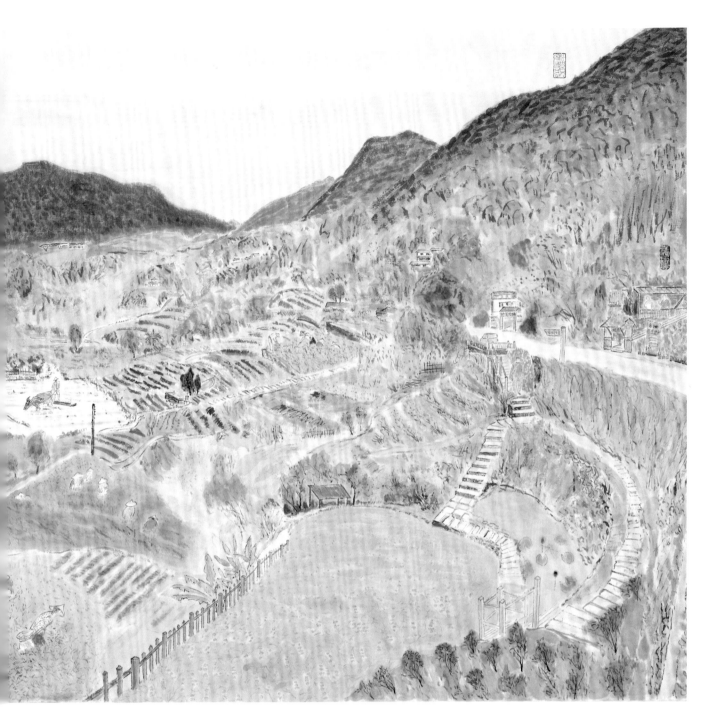

返回自然之夢

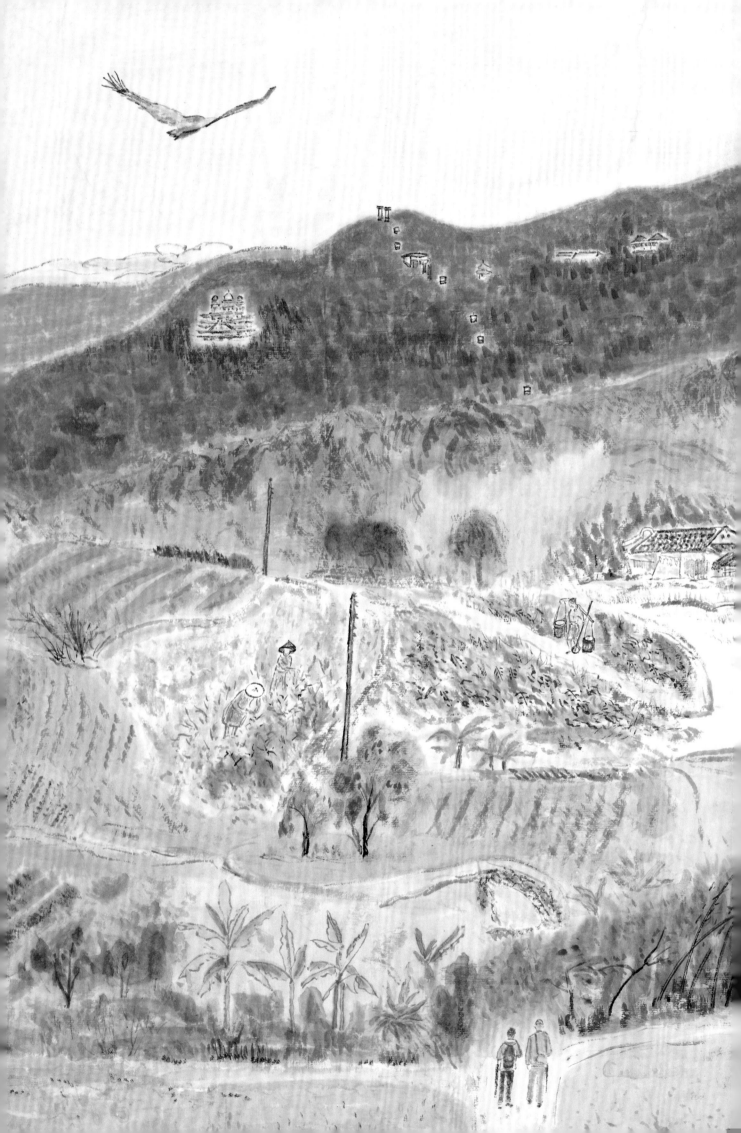

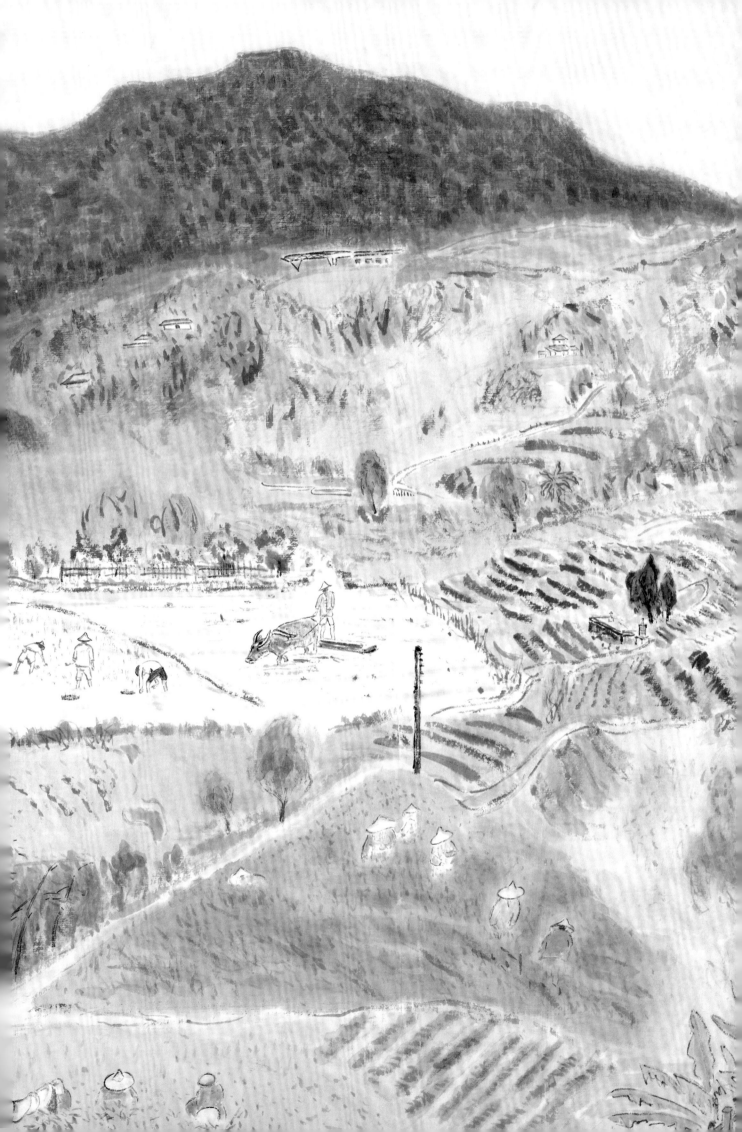

浮生／走過一甲子｜180×96cm｜2013｜宣紙・彩墨

Fleeting Life / After Six Decades | colored ink on xuan paper

看見臺北之一｜Seeing Taipei 1

看見臺北（三連作）｜每作64×101cm

2013｜日本紙・水墨

Seeing Taipei (triptych)
colored ink on Japanese paper

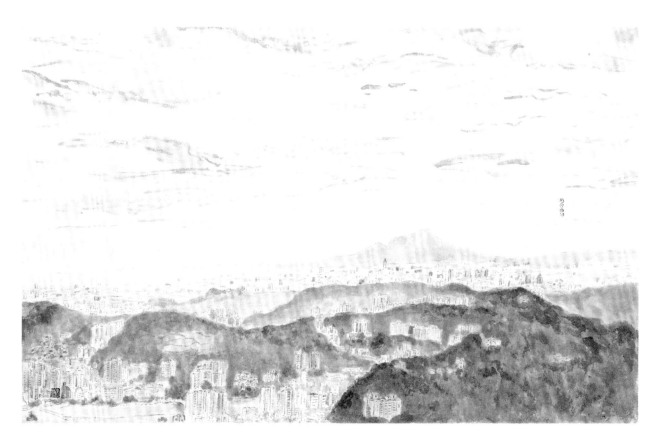

看見臺北之二｜Seeing Taipei 2

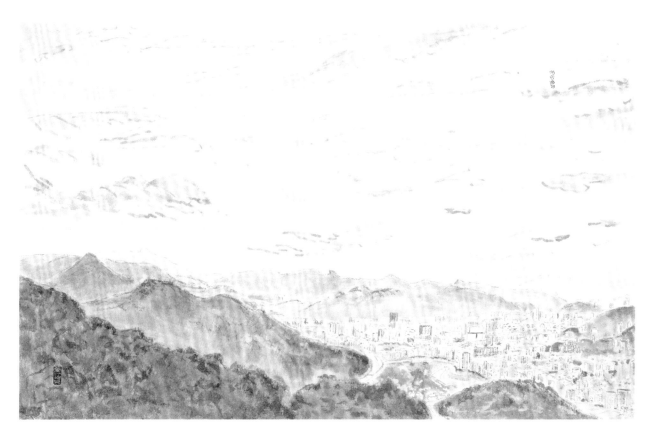

看見臺北之三｜Seeing Taipei 3

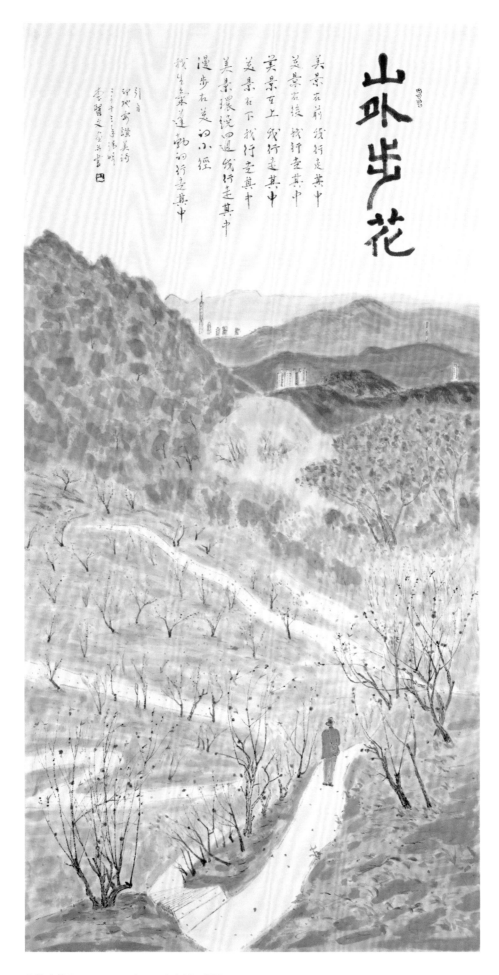

山外步花 | 138×70cm | 2013 | 宣紙 · 彩墨

Strolling In the Mountains Amidst Flowers | colored ink on xuan paper

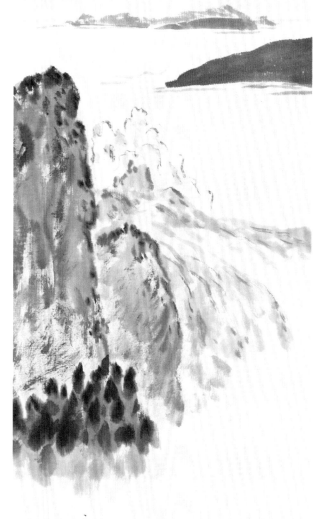

清閒為尚
靈曠為懷

【山外步花 釋文】

美景在前，我行走其中；
美景在後，我行走其中。
美景在上，我行走其中；
美景在下，我行走其中。
美景環繞四周，我行走其中；
漫步在美的小徑，我生氣蓬勃地行走其中。

引自印第安讚美詩，兩千十三年清明李賢文畫並書。

Strolling In the Mountains Amidst Flowers

With beauty before me may I walk
With beauty behind me may I walk
With beauty above me may I walk
With beauty below me may I walk
With beauty all around me may I walk
Wandering on a trail of beauty, lively, may I walk

Excerpt from a Navajo Prayer; painted and inscribed by
Lee Shien-Wen in 2013 on Tomb-Sweeping Day.

虛曠為懷｜97×33.5cm｜2013｜王國財手工紙·水墨

Vast and Broad｜colored ink on handmade paper by Wang Kuo-Tsai

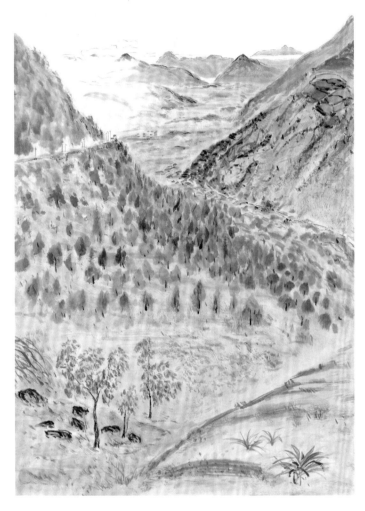
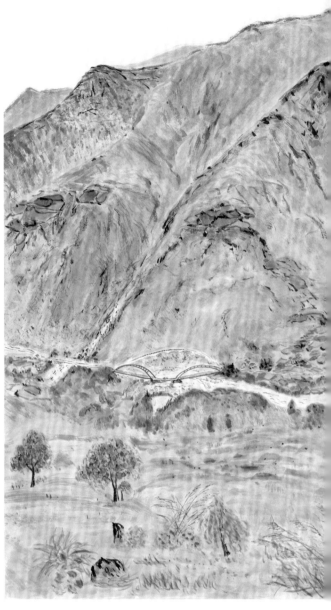

日升月恆（四聯軸）｜每軸176×81.2cm

2012｜宣紙・彩墨

Eternal Sun and Moon (tetraptych)
colored ink on xuan paper

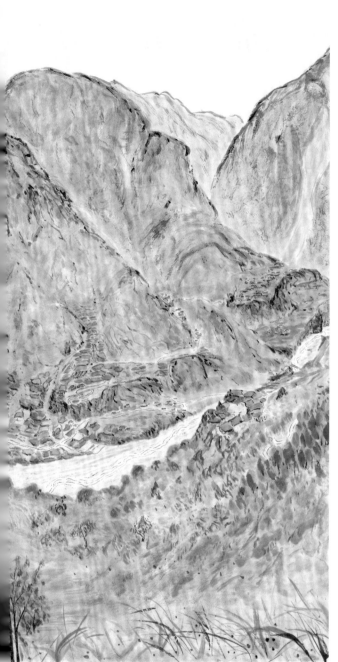
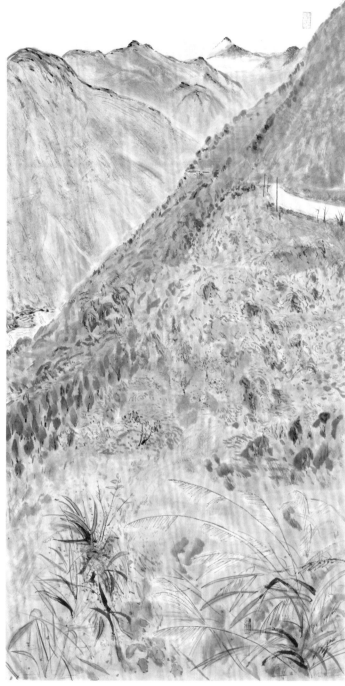

【釋文】

寫生行旅年來，幾度行經新中橫，沿途中央山脈翠嶂綿延，深溪縱谷曲折迤邐。二〇一一年歲末復由新中橫往塔塔加寫生時，赫見東埔日橋月橋，雙橋新竣，橫跨陳有蘭溪，朱紅映碧照人耳目，群山萬綠中，朱紅雙橋不僅沁人心脾，朝曦夕暮之時更見精神。雙橋並立如日之升如月之恆，銜接城鄉資聚部落豐饒興旺，年年歲歲日月不息，感此深意遂記寫日升月恆四聯屏於二〇一二年立夏。李賢文畫並題。

Eternal Sun and Moon

I've been painting while traveling for years, and have crossed the New Central Cross-island Highway on several occasions, where the rolling jade-like Central Mountains and deep, winding creeks and valleys are seen along the way. At the end of the year 2011 while traveling on the New Central Cross-island Highway towards Tataka to paint on location, I was taken aback by the Dongpu Sun & Moon Twin Bridges stretching across the Danyulan River, with the red bridges standing out brightly amidst the vast green mountains. The sight was quite delightful and exhilarating. The twin bridges represent the sun and the moon and connect townships and tribes, bringing in prosperity year after year, eternally. This tetraptych, Eternal Sun and Moon, was inspired by this experience in the summer of 2012; painted and inscribed by Lee Shien-Wen.

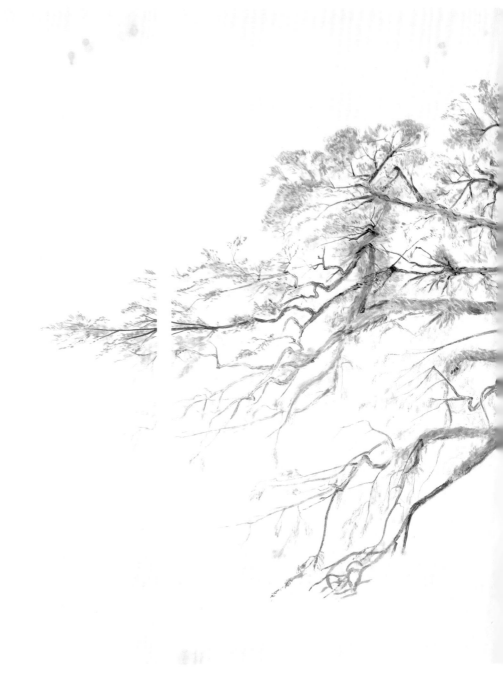

塔塔加大鐵杉（四聯屏）│每屏176×96cm

2011│宣紙・彩墨

| Taiwan Hemlock on Tataka (tetraptych)
| colored ink on xuan paper

【左釋文】

畫大鐵杉時行筆宜遲疾並濟，偶而點染針葉偶而皴擦肌理，
須於筆酣墨暢，意有未盡之時，停筆稍歇，或凝視近景或
遠觀全局或游目窗外或打坐喝茶，在意盡而筆未竟之前停
步留白，不汲汲於終章，不競奔於陋習，止息靜觀，心靜
則筆淨，念念淨則筆筆敬，如此清幽曠達自在其中。

畫於民國百年歲末　書於壬辰龍年元宵　李賢文於五苓山居

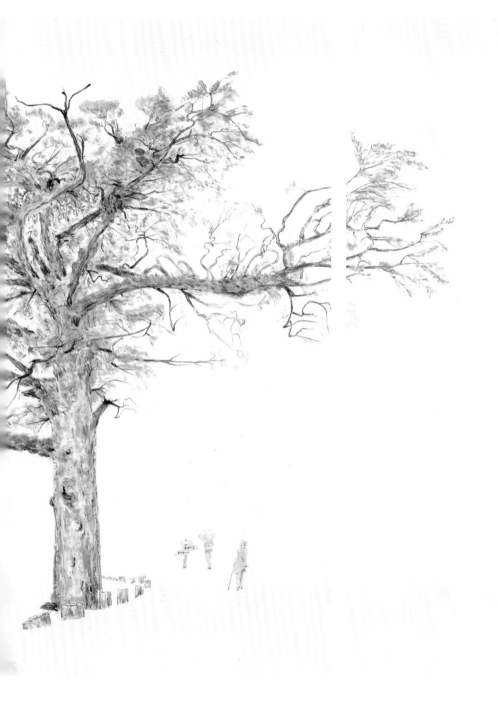

塔塔加大鐵杉

【右釋文】

民國百年雙十南投行,逕入塔塔加,再探大鐵杉。巍峨
華蓋,鐵幹翠羽。分枝散葉,盤根錯節。俯察其源,根
著於低濕仄谷,仰視其表則布展開張;磅礴蒼樸,其枝
益繁而葉分益密,主幹壯實,虯結麟皮。樹齡八百,徑
可四人圍。其生發有序,廓然可觀,主枝分次。次枝分
細,細枝分幼,幼枝出葉,疊疊層層,葉葉心心,理緒
昭昭。惟因山高澗多,日夕氤氳,雲蒸霞蔚,流謙潤下。
地衣、松蘿、薜荔、鳥巢蕨,菌孢之屬,輾轉生附於鐵
杉枝椏之上,遠望綠雲紛披,翠碧可愛,近觀則物物相
生,有容乃大。此大鐵杉,遠世塵而氣益清,居玉山腳,
迎登山客,獨而不孤,頂天立地,堂堂大樹,澤及萬物。

087

玉山有待圖 ｜ 137×70cm ｜ 2007 ｜ 宣紙・彩墨 ｜ Mount Jade Eternally Awaits ｜ colored ink on xuan paper

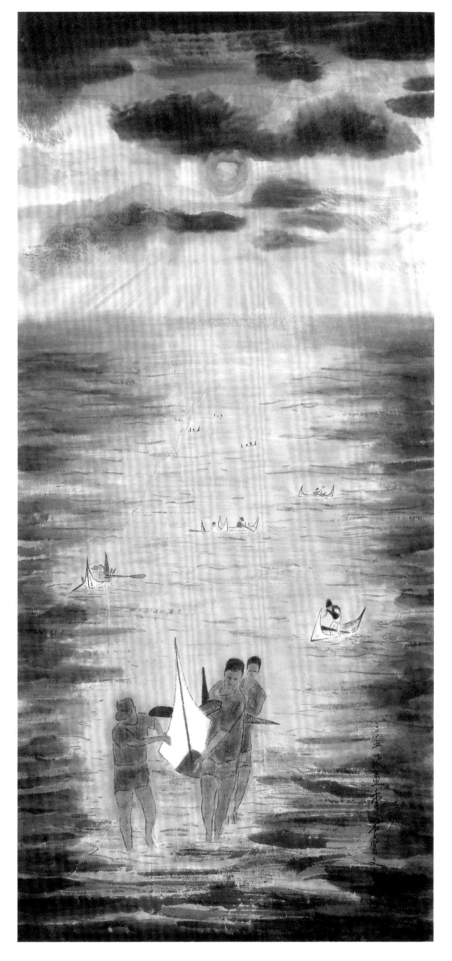

飛魚季｜96.5×44cm｜2005｜宣紙・彩墨　｜　Flying-fish Season｜colored ink on xuan paper

玉山曉月 | 33×97cm

2005 | 王國財手工紙 · 彩墨

Mount Jade and the Moon
colored ink on handmade paper by Wang Kuo-Tsai

人間清曠 | 96.5×44cm | 2005 | 宣紙・彩墨

Life of Refreshing Openness | colored ink on xuan paper

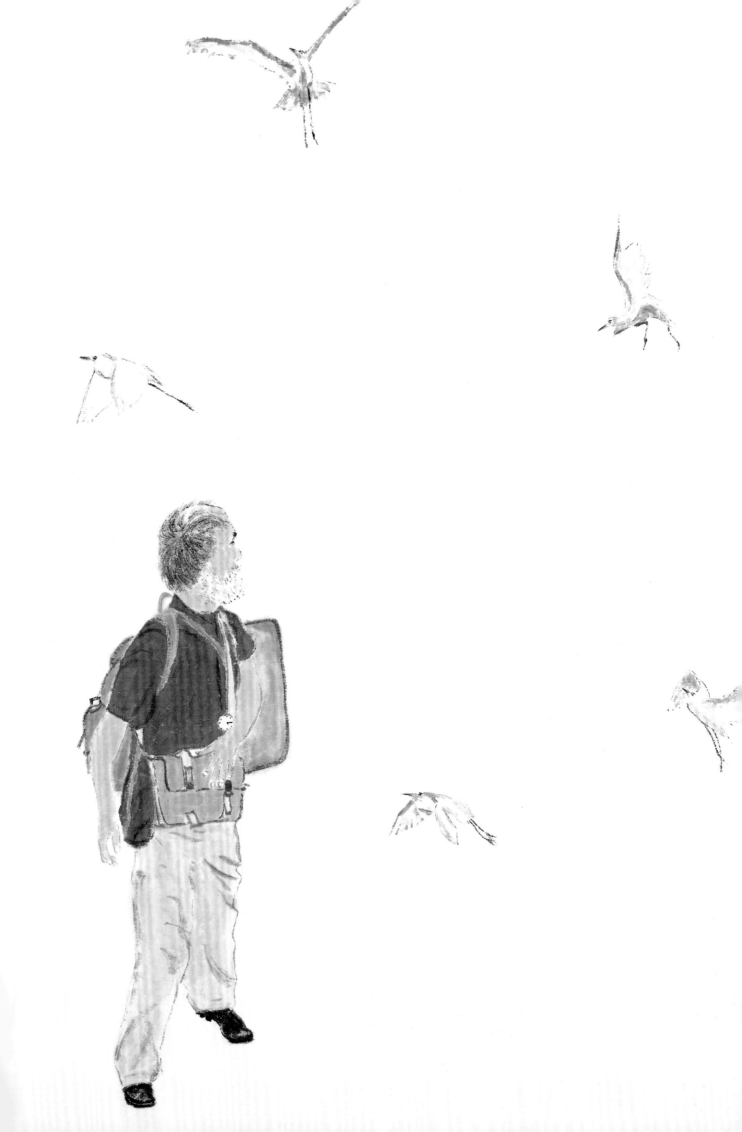

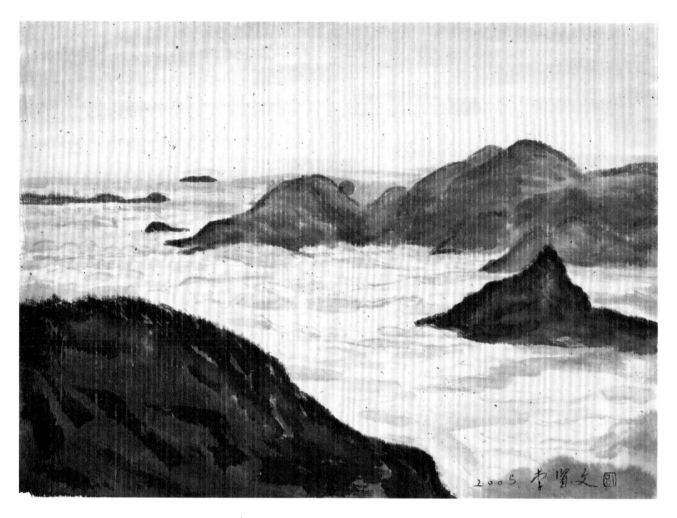

月出八通關 | 33.2×24cm | 2005 | 宣紙・彩墨 | Rising Moon at Pantounkua | colored ink on xuan paper

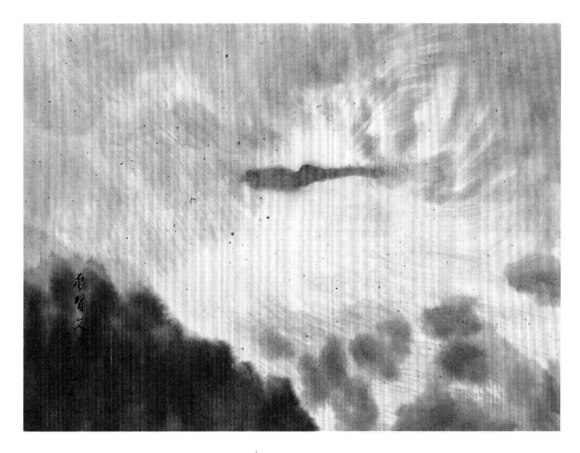

夕陽開一角｜33.2×24.4cm｜2005｜宣紙・彩墨 ｜ A Smidgen of the Setting Sun｜colored ink on xuan paper

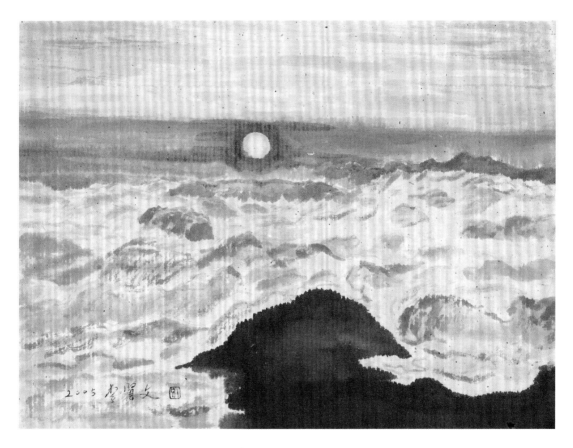

霞披玉山｜33.5×24.2cm｜2005｜宣紙・彩墨 ｜ Rosy Clouds over Mount Jade｜colored ink on xuan paper

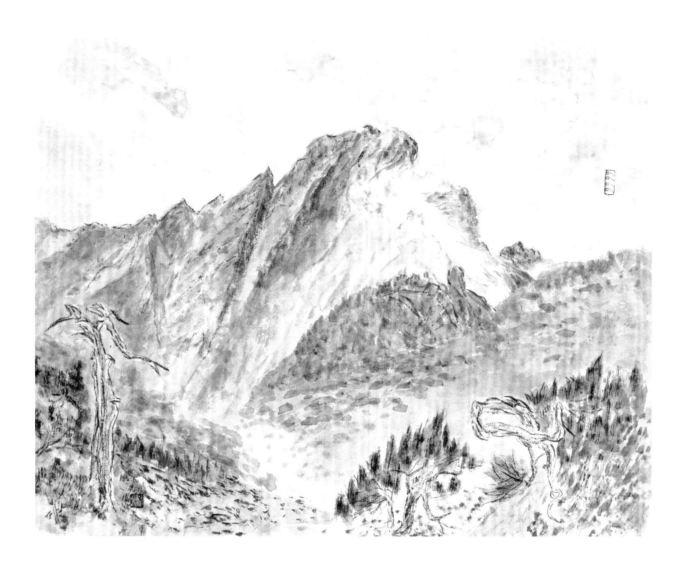

秋雲縈峰 | 27.5 × 35cm

2004 | 宣紙・彩墨

Autumn Clouds Curling over the Peak
colored ink on xuan paper

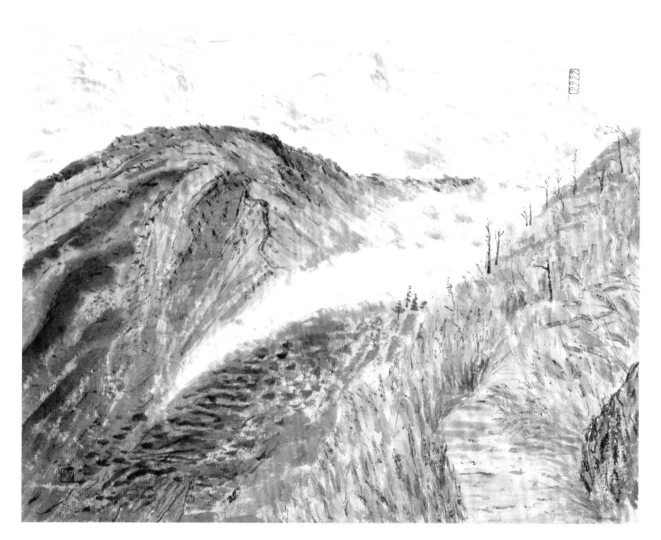

出岫閒雲 | 27.5×35cm

2004 | 宣紙・彩墨

Clouds Emerging from the Mountain
colored ink on xuan paper

返回自然之夢

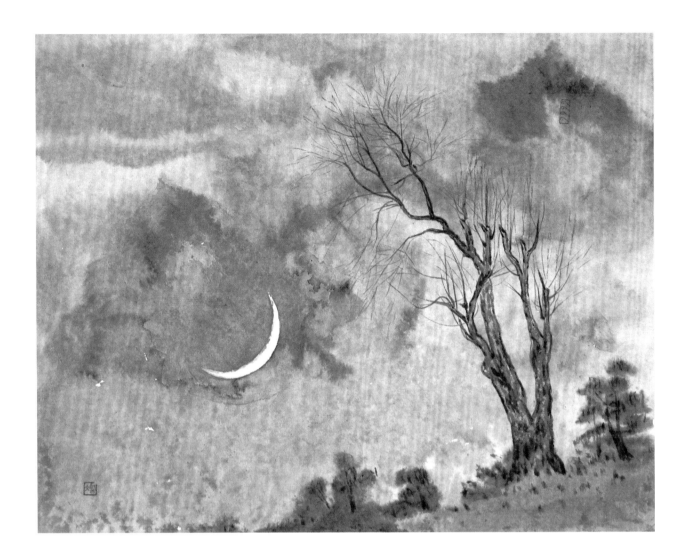

鑲嵌弦月 | 27.5×35cm

2004 | 宣紙·彩墨

Encrusted with the Crescent Moon
colored ink on xuan paper

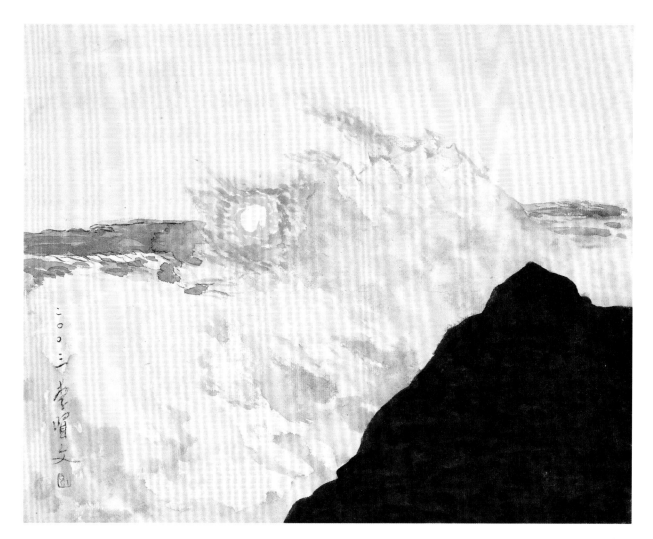

玉山日出 | 27 × 35 cm

2003 | 宣紙・彩墨

Sunrise over Mount Jade
colored ink on xuan paper

八通關古道漫遊冊頁（十一面）｜每面28×38cm

2003｜宣紙・彩墨

Booklet of Strolls through the
Pantounkua Ancient Trail (11 pages)
colored ink on xuan paper

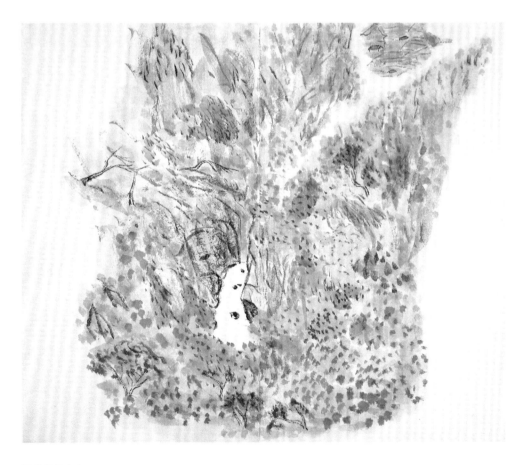

香格里拉｜Shangri-La

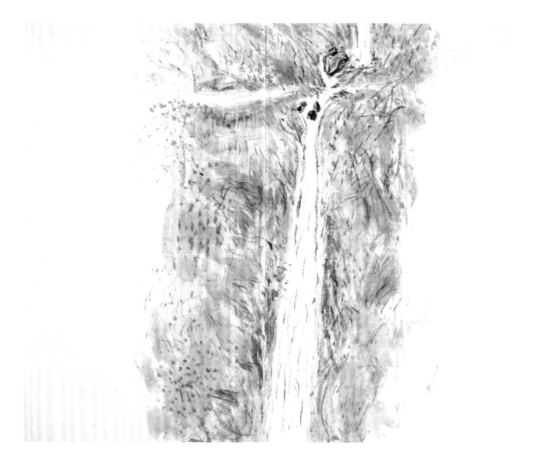

雲龍瀑布 | Yunlong Waterfall

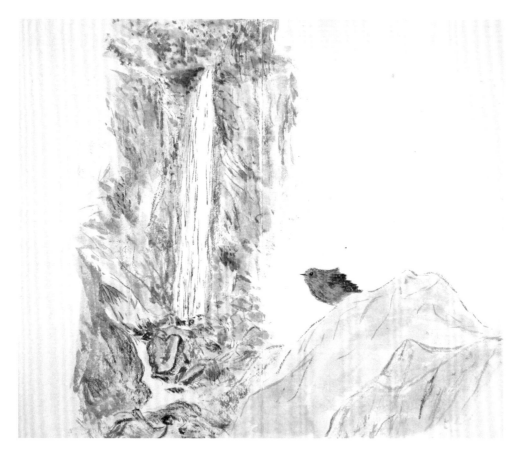

鉛色水鶇 | Plumbeous Water Redstart

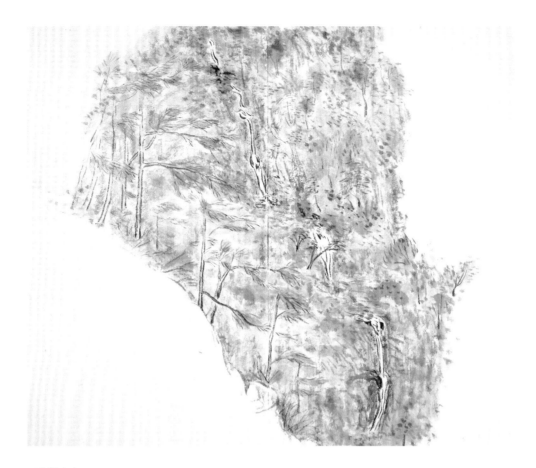

乙女瀑布 | Yinu Waterfall

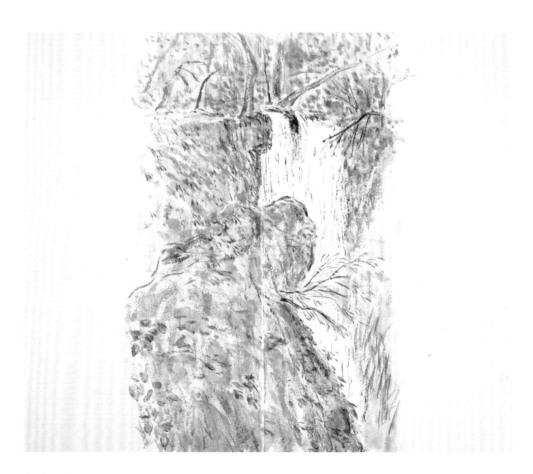

眾情奔悅 | Delighted

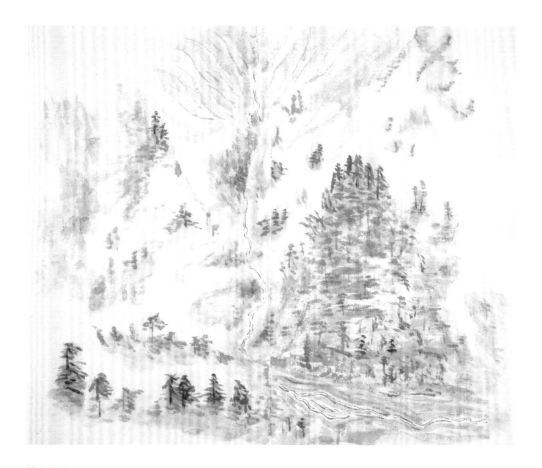

陳有蘭溪 | Danyulan River

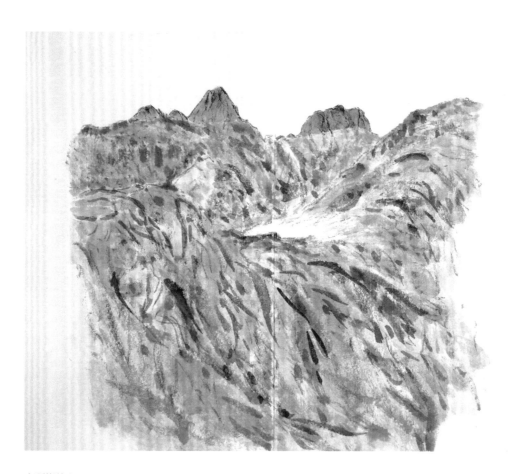

山頭燦然 | Dazzling Mountain Top

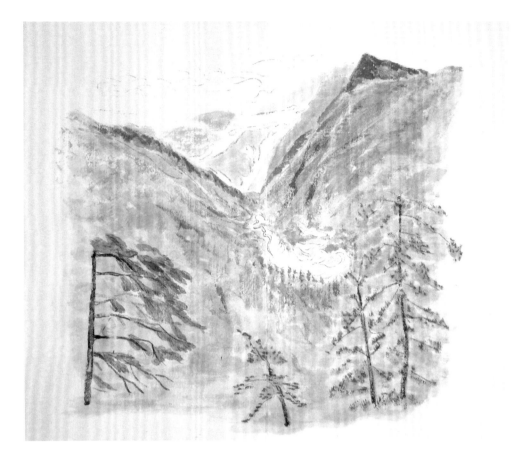

漫遊所見 | Scene from the Stroll

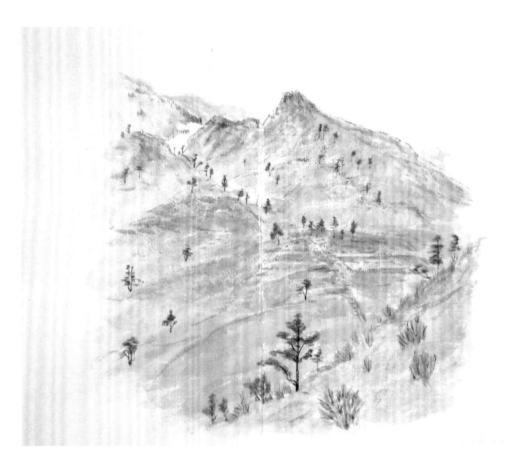

八通關草原 | Pantounkua Grassland

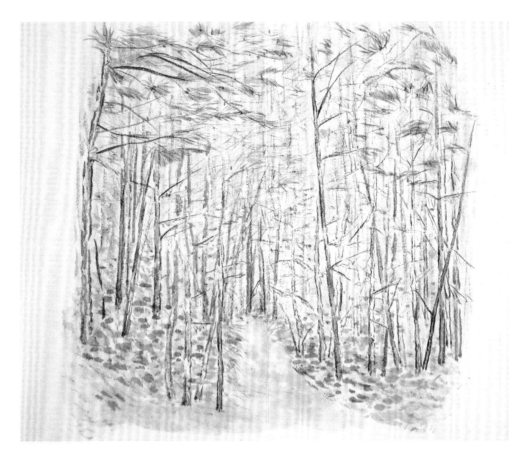

二葉松林 | Taiwan Red Pine Forest

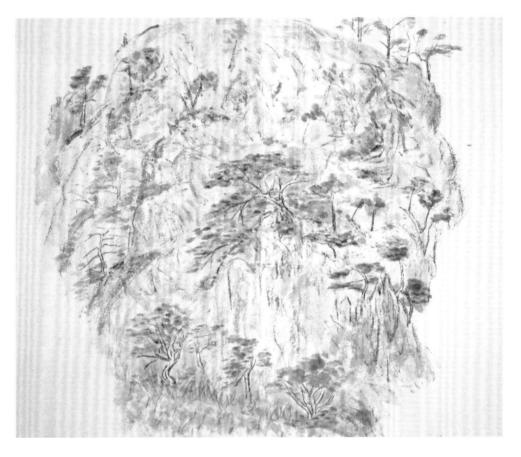

八通關山 | Pantounkua Mountain

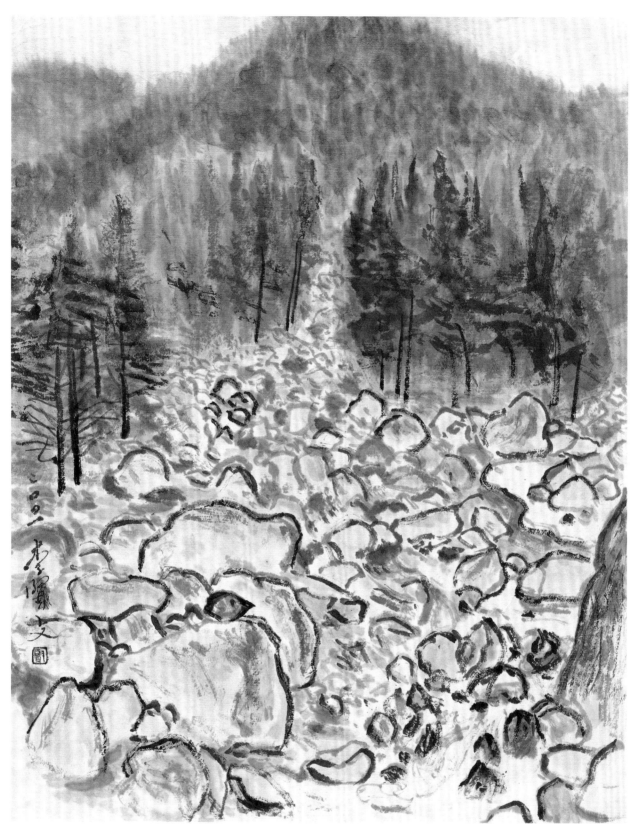

土石流 | Landslide

流變十圖 | 每面27.5×35cm

2001 | 宣紙・彩墨

Ten Illustrations of Flowing Changes
colored ink on xuan paper

流變十圖木盒

鬱結 | Troubling Knots

落難 | Adversity

返回自然之夢

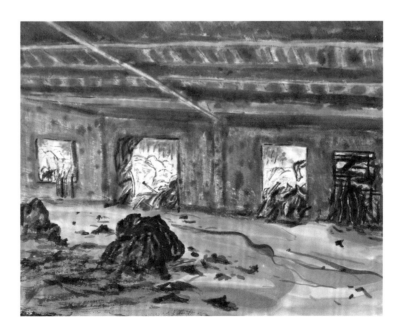

破牆 | Shattered Walls

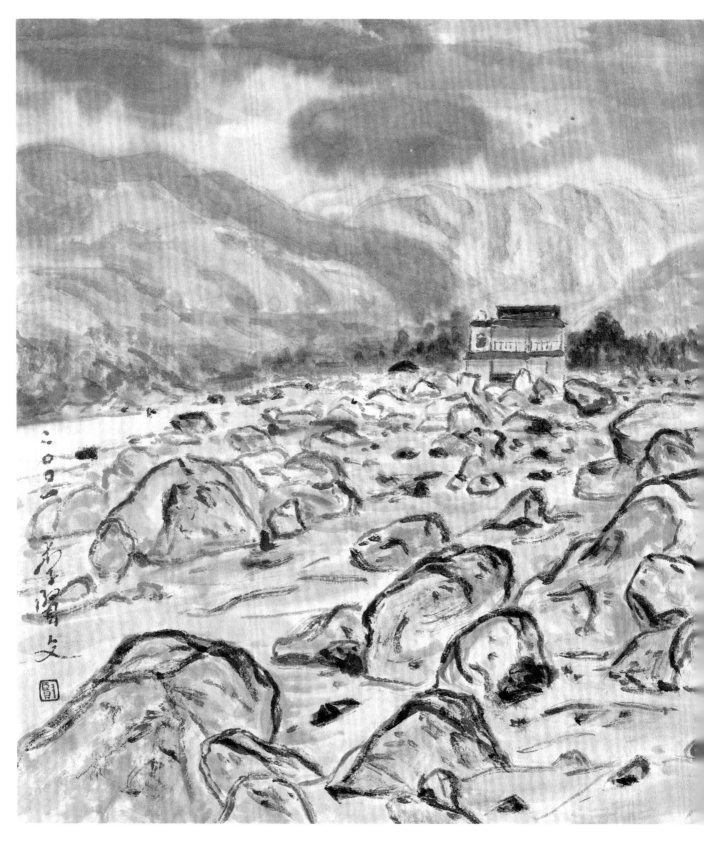

流變 | Flowing Changes

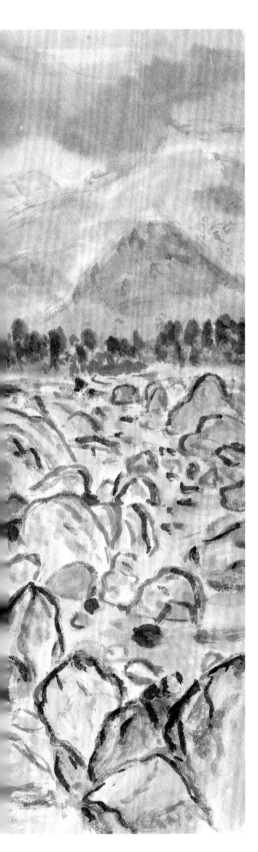

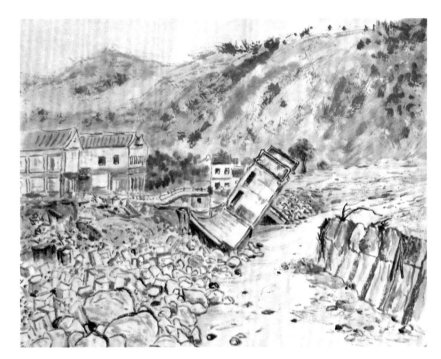

樓塌｜Toppled

搶通｜Rush Through Urgently

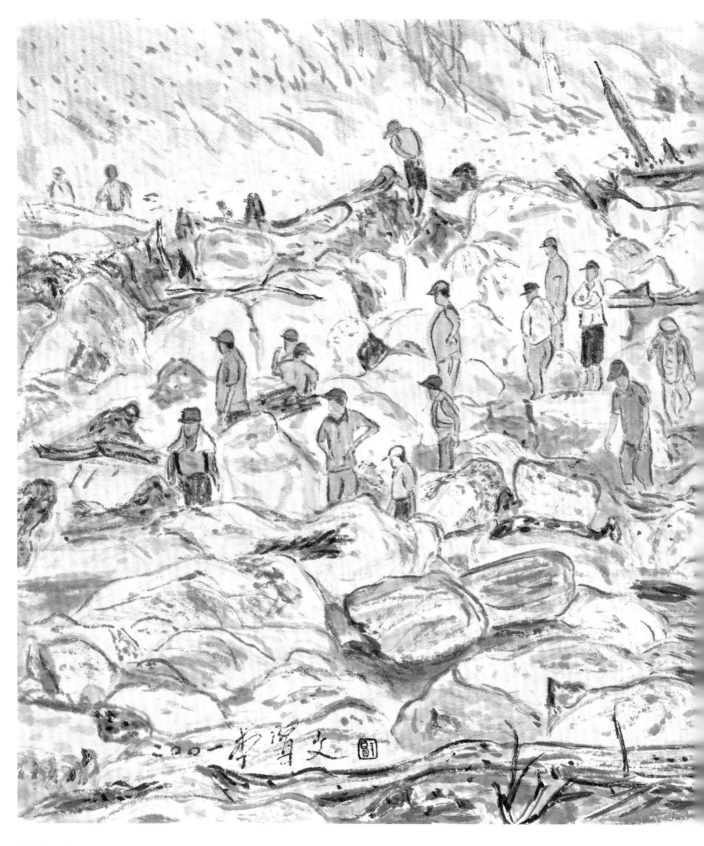

尋 | Searching

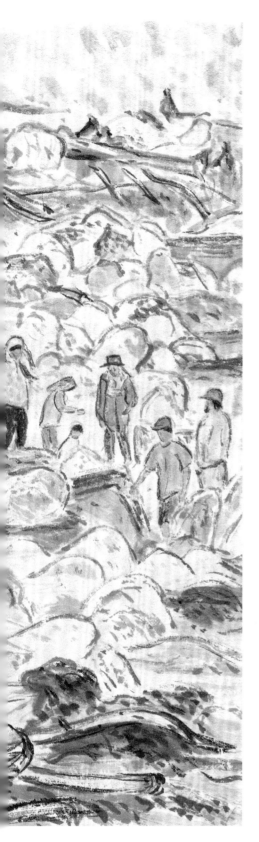

搶救 | Emergency Rescue

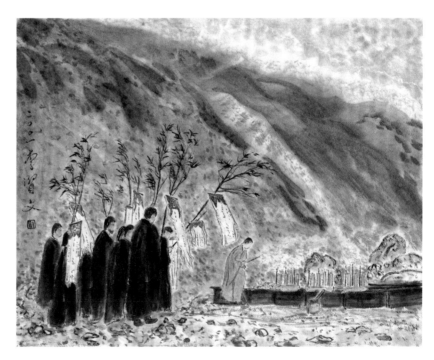

招魂 | Summoning the Spirits

雪霸登高圖（四聯屏）

155×200cm

2000｜宣紙・彩墨

Climbing Shei-Pa (tetraptych)
colored ink on xuan paper

雪霸登高圖

登高難，不忘 ... 有心即不難 ... 藝術登高難，有心 ... 雪霸登高 ... 詩并畫李賢文

返回自然之夢

【釋文】

李賢文畫並有詩云：

雪霸登高難，有心即不難；
藝術登高難，有心猶更難。
寫生以無心，趣味自然生；
創作時有窮，傳統覓活泉。
停筆廿五載，水墨今自性；
雪霸登高圖，償我多年情。

千禧年‧中秋佳日記

Climbing Shei-Pa

A painting and poem by
Lee Shien-Wen:
Mount Shei-Pa is a daunting climb, with
determination it is surmountable; Art is
a daunting climb, with determination
it perhaps becomes more challenging.
Painting outdoors is unpremeditated,
with delightful amusements naturally
sprung; Inspiration may sometimes
be scarce; in tradition is where a vital
spring is found. After putting down the
brush for 25 years, in ink and water the
Self is found; Climbing Shei-Pa, with
years of emotions reclaimed.

Written on Mid-Autumn day in 2000

113

雪霸登高圖_局部

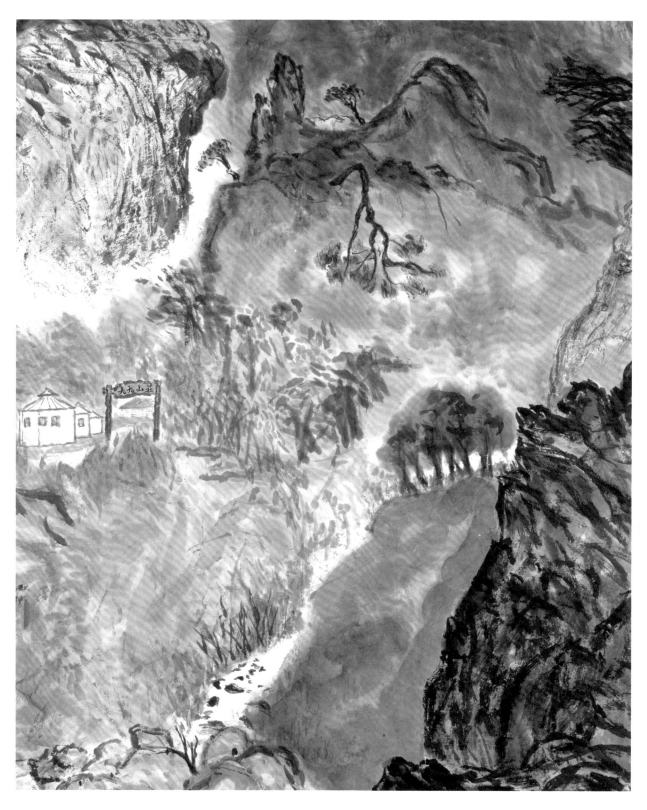

雪霸登高圖_局部

李賢文創作年表

1947 ——————·出生於臺北市近圓環的太原路。

1961 ┃ 14歲 ——·啟蒙老師何肇衢教導油畫。

·油畫作品〔窗邊靜物〕入選第十六屆省展，以後連續四年入選省展，奠定寫生創作的濃厚興趣。

窗邊靜物
1961 ┃ 油畫
┃ Still-life by the Window ┃ oil

1962 ┃ 15歲 ——·油畫作品〔北投風光〕榮獲全省學生美展初中部第一名，建立了美術創作的信心。

1964 ┃ 17歲 ——·與師大附中寫生同好，籌組「師大附中寫生會」，並擔任首屆會長，培養了藝術行政之基本能力。

1969 ┃ 22歲 ——·於就讀之輔仁大學舉行首次水彩油畫個展，畫家席德進、張杰蒞臨指導。

1970 ┃ 23歲 ——·在畫家劉其偉的鼓勵與協助之下，於臺北市精工舍畫廊舉行水彩個展。

1971 ┃ 24歲 ——·水彩作品〔海頌〕榮獲第六屆全國美展佳作。

·在父親李阿目的支持下，創辦《雄獅美術》月刊，擔任發行人，從而投入臺灣美術文化的推廣。

1972 ┃ 25歲 ——·創立雄獅圖書股份有限公司，開始美術文化叢書的出版工作。

1973 ┃ 26歲 ——·前往法國遊學二年，期間與海外學人廣泛交流，包括奚淞、蔣勳、熊秉明、李明明、侯錦郎、陳錦芳、
蕭勤等，因而開展了國際視野。

1979 ┃ 32歲 ——·二年間在月刊策劃出版了黃土水、顏水龍、陳澄波等十九位臺灣前輩美術家專輯，
無形中深化個人對本土美術文化的認識。

1984 ┃ 37歲 ——·創立「雄獅畫廊」至1994年止，共舉行了154次展覽。見證也參與了當代美術文化的進程。

1986 ┃ 39歲 ——·應美國在臺協會之邀，走訪美國各地美術文化公私立機構為期一個月。返臺後，推動「公共藝術」之理念。

1990 ┃ 43歲 ——·畫家余承堯示範一張水墨畫，並在畫上題「賢文學畫第一章」。同時教授要「多讀書多寫字」。

1992 ┃ 45歲 ——·從書法家楊子雲學古隸，臨《好大王碑》。

1995 ┃ 48歲 ——·往印度大吉嶺、菩提伽耶旅行寫生，開始嘗試以筆墨寫生。

1996 ┃ 49歲 ——·拜九十歲書法家陳雲程為師，學習行草。臨王羲之字帖時，提點行草不論筆走龍蛇，
背後要有一根看不見的中軸線。

·《雄獅美術》月刊停刊，歷經307期，二十五年又七個月，發表〈停刊的話——結束是另一生機的啟端〉！

1997 ┃ 50歲 ——·往北京拜師賈又福學習水墨畫，三年間，九度赴北京習畫，賈老師強調創作須向最高峰學，
遂臨摹龔賢、范寬與石濤作品。

2000 ┃ 53歲 ——·創作〔雪霸登高圖〕四聯屏（155×200cm），日本設計家杉浦康平觀此作，
指出其身體裡古老的生命記憶已被喚起。

Chronology of Lee Shien-Wen

1947 —— · Born on Taiyuan Road near Taipei's iconic roundabout.

1961 | 14 years old —— · Began learning oil painting under the tutelage of Ho Chau-Chu.
· Oil panting, *Still-life by the Window*, selected for the 16th Taiwan Provincial Fine Art Exhibition, followed by nominations in the four consecutive years thereafter, which helped to foster Lee's strong interest for plein air painting.

1962 | 15 years old —— · Oil painting, *Landscape of Beitou*, awarded first prize in the Taiwan Provincial Fine Art Student Exhibition – Junior High School Category, with Lee gaining more confidence in art.

1964 | 17 years old —— · Founded a plein air painting club with other art aficionados from the Affiliated Senior High School of National Taiwan Normal University and also served as the club's first president, and it was during this time that he began to attain basic art administration skills.

1969 | 22 years old —— · Presented his first watercolor and oil painting solo exhibition at Fu Jen Catholic University where he was attending at that time. Painters Hsi Te-Chin and Chang Chieh visited the exhibition.

1970 | 23 years old —— · Presented a watercolor painting solo exhibition at Seikosha Gallery with encouragement and support from painter, Max Liu.

1971 | 24 years old —— · Watercolor painting, *Song of the Sea*, awarded with merit award at the 6th National Art Exhibition of ROC.
· Published the inaugural issue of *The Lion Art Monthly* with the support of his father, Lee A-Mu. Lee served as the magazine's publisher and also began devoting himself in advocating art and culture in Taiwan.

1972 | 25 years old —— · Founded Hsiung-Shih Art (Lion Art) Books and began publishing art and culture books.

1973 | 26 years old —— · Studied abroad in France for two years where he met and interacted with other overseas intellectuals, including Shi Song, Chiang Hsun, Hsiung Ping-Ming, Lee Ming-Ming, Hou Chin-Lang, Chen Tsing-Fang, and Hsiao Chin, with his international horizons broadened by the experience.

1979 | 32 years old —— · Published monographs in a span of two years through the *Lion Art Monthly* for 19 Taiwanese veteran artists including Huang Tu-Shui, Yen Shui-Long, and Chen Cheng-Po, with the experience also fortified his personal understanding for local art and culture.

1984 | 37 years old —— · Witnessed and took part in the progression of contemporary art and culture through Hsiung Shih Gallery that he founded, presenting a total of 154 exhibitions till 1994.

1986 | 39 years old —— · Invited by the American Institute in Taiwan for a one-month visit of different public and private art and cultural institutions in the U.S., and began advocating "public art" upon his return.

2001｜54歲 ── ·1999年九二一大地震後，兩年間經常往南投災區探訪寫生，並三次登臨災後九九峰，
　　　　　　　遂完成〔三探九九峰〕水墨長卷（60×2862cm，畫心2054cm）
　　　　　　·旅法藝術家熊秉明曾跋此作「寫峰巒湖海用自家之法，追客觀之實貌，不因襲古人舊規。」

三探九九峰_局部
2001｜宣紙·水墨
Three Visits to Mount Chiu-chiu
(partial view) ink on xuan paper

2004｜57歲 ── ·創作〔群玉山頭〕彩墨（106×230cm）。由2002年至2005年七次上玉山寫生。
　　　　　　　與畫友盧廷清、鄭治桂於福華沙龍舉行「群玉山頭三人展」並合作出版《群玉山頭》。

群玉山頭｜106×230cm
2004｜宣紙·彩墨
The Tip of Mount Jade
colored ink on xuan paper

2005｜58歲 ── ·因臺灣百年大雪而上合歡山，創作〔百年大雪武嶺行〕水墨橫卷（23×788cm，畫心560cm）。
　　　　　　　2009年創作《合歡道上》冊頁（42×643cm）。前者在畫室創作，後者在現場寫生，呈現不同的心境與筆法。
2009｜62歲 ── ·因嚮往日本障壁畫，而在自宅「五苓山居」創作門屏畫，三年間分別畫製〔世界荷塘〕、
　　　　　　　〔春之五苓〕與〔塔塔加大鐵杉〕四聯屏，每屏176×96cm。

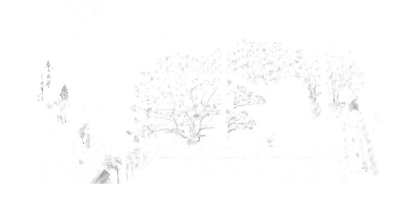

春之五苓（四聯屏）
2009｜宣紙·彩墨
Wuling in Spring (tetraptych)
colored ink on xuan paper

2010｜63歲 ── ·拜九十六歲張光賓習字，臨寫草書《書譜》與漢隸《鮮于璜碑》。教導「遇轉則提」的道理。
2011｜64歲 ── ·應臺北藝境畫廊之邀，出品「蒼樸·清曠 筆墨情──張光賓、李賢文雙人展」。

1990 | 43 years old —— · Painter Yu Chen-Yao inscribed on a demonstration ink painting, "Shien-Wen's first chapter in learning how to paint", and he also encouraged Lee to "read more and write more."

1992 | 45 years old —— · Studied and practiced the ancient clerical script under the tutelage of Chinese calligrapher, Yang Tze-Yun, and transcribed *The Gwanggaeto Stele*.

1995 | 48 years old —— · Traveled to Darjeeling and Bodhgaya, India and painted while traveling. It was during this time that he began using brush and ink to create plein air paintings.

1996 | 49 years old —— · Studied and practiced the cursive script under the tutelage of 90-year old Chinese calligrapher, Chen Yun-Cheng, and transcribed Wang Xi-Zhi's *Calligraphy Reference Book*. He was given the advise that regardless of how free-flowing one's cursive script appears to be, always bear in mind to keep an invisible central axis line on one's backbone.
· After 307 issues, 25 years and 7 months, *The Lion Art Monthly* came to a close, with Lee releasing an essay titled, *Words for Our Last Issue – Ending is To Begin Another Life!*

1997 | 50 years old —— · Studied and practiced ink painting under the tutelage of Jia You-Fu in Beijing, with Lee traveling to Beijing nine times in the span of three years. Master Jia placed emphasis on learning from the best when creating art, and thus, Lee replicated paintings by Gong Xian, Fan Kuan, and Shi Tao to learn from the old masters.

2000 | 53 years old —— · Painted *Climbing Shei-Pa* (tetraptych, 155×200cm). After seeing this work, Japanese designer Kohei Sugiura expressed that the ancient memories of life dwelling in his body were awakened by the artwork.

2001 | 54 years old —— · Began visiting disaster-stricken areas in Nantou after Taiwan's 921 earthquake in 1999, and painted on location. Climbed Mt. Chiu-chiu three times after the earthquake and completed the long ink scroll titled, *Three Visits to Mount Chiu-chiu*. (60×2862cm, middle of the scroll 2054cm)
· Artist Hsiung Ping-Ming, who resided in France, wrote the following after seeing the artwork, "The depiction of the landscape was truly original, with distinctive, subjective features that were unrestricted by ancient rules."

2004 | 57 years old —— · Worked on colored ink painting, *The Tip of Mount Jade*, (106×230cm). Painted on Mount Jade seven times between 2002 and 2005 and presented a join exhibition with artists Lu Ting-Ching and Cheng Chih-Kuei at Howard Salon, titled *The Tip of Mount Jade Trio Exhibition*. The three also co-published a book with the same title.

2005 | 58 years old —— · Climbed Mount Hehuan after Taiwan's greatest snowstorm in a hundred years and created *Climbing Wuling on a Day with the Biggest Snowstorm in the Past Century*, a horizontal ink scroll (23×788cm, middle of the scroll 560cm), followed by *On the Trail on Mount Hehuan* in 2009 (pamphlet, 42×643cm). The former was painted in a studio, and the later was painted on location, showcasing different mindsets and brushwork.

2009 | 62 years old —— · Due to his appreciation for Japanese wall paintings, Lee painted screen door paintings in his residence, Wuling House, creating the following tetraptychs in the span of three years: *The World is a Lotus Pond*, *Wuling in Spring*, and *Taiwan Hemlock on Tataka*. Each screen is 176×96cm in size.

2010 | 63 years old —— · Studied and practiced calligraphy under the tutelage of the 96-year old Chang Guang-Bin and transcribed *The Treaties on Calligraphy* in cursive script and *The Stele of Xianyu Huang* in Han clerical script.

2012｜65歲——・創作〔日升月恆〕四聯屏，每屏176×81.2cm。藝評家江衍疇論此作「史實意味濃厚，
　　　　　　　　迥異於文人水墨借景寄情的旨趣。」

　　　　　　・應中央大學藝文中心之邀，舉行「人間清曠」水墨畫個展，
　　　　　　　出版《人間清曠——五苓山居水墨筆記》，並獲金鼎獎。

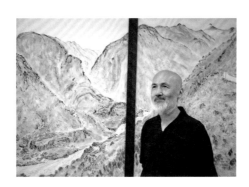

李賢文與其創作「日升月恆」四聯屏合影。(張大川攝)

Lee Shien-Wen and his tetraptych, *Eternal Sun and Moon*.
(Photograph by Chang Da-Chuan)

2013｜66歲——・擔任政大駐校藝術家，以一年為期創作。而有〔貓空百年茶事〕(105×231cm)、〔浮生/走過一甲子〕
　　　　　　　(180×96cm)等作品。此二作以貓空為對象，並以蒙太奇手法畫出了木柵地區的過去與現在。

　　　　　　・出版《美的軌跡——那些人・那些事・那些夢》集結雄獅美術四十二年記三十三篇，於《今藝術》連載的文章。

2014｜67歲——・應政大藝文中心之邀，舉行「文山春秋」水墨個展並出版《文山春秋——水墨浮世流光》。

　　　　　　・擔任臺東大學駐校藝術家，創作〔山迴路轉尋油杉〕、〔迭宕起伏探牛樟〕(各232×52.8cm)等作品。
　　　　　　嘗試以留白的手法，切換時間與空間，探索虛實相生的美學觀。
　　　　　　藝評家白適銘評述此兩件利用古代橫卷敘事畫常見的「一圖多時」法並將它倒置成掛軸來加以呈現。

2015｜68歲——・應臺北藝境畫廊之邀，舉行「光之道——李賢文水墨行旅個展」。

2016｜69歲——・創作【返回自然之夢】，蘭嶼組畫九幅，每幅130×65.5cm。組畫乃呼應艾格里神父之歎，
　　　　　　　「承受蘭嶼巨大的轉變，然而即使我對這座島嶼的嚮往開始幻滅，但在我心裡那美麗的夢境將永遠存在」。

2017｜70歲——・出版《後山有愛》，集結2005至2006年間在《文訊》月刊發表之臺東圖文創作。

　　　　　　・應國立歷史博物館之邀，舉行「返回自然之夢——李賢文畫展」。

山迴路轉尋油杉｜232×52.5cm
2013｜宣紙・彩墨

Searching for the Taiwan Cow-tail Fir
on Winding Mountain Paths
colored ink on xuan paper

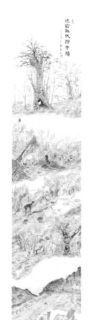

迭宕起伏探牛樟｜232×52.8cm
2014｜宣紙・彩墨

Discovering the Hayata On Rolling Trails
colored ink on xuan paper

2011 | 64 years old —— · Invited by Artdoor Gallery in Taipei for the duo-exhibition, *Simplicity Meets Ethereality: A Passion for the Spirit of Painting*, with Chang Guang-Bin.

2012 | 65 years old —— · Created the tetraptych, *Eternal Sun and Moon*, with each screen 176×81.2cm in size. Art critic Chiang Yen-Chou described the painting as, "An interesting work with rich historical accuracy but also different from literati's transference approach for landscape ink paintings."
· Presented *A Path to Hidden Beauty-Lee Shien-Wen's Solo Exhibition* at National Central University's Art & Culture Center. Also published *A Path to Hidden Beauty – Notes with ink at the Wuling House*, which received the Golden Tripod Award.

2013 | 66 years old —— · Became a resident artist at National Chengchi University for a year, and created artworks including *A Hundred Years of Tea in Maokong* (105×231cm) and *Fleeting Life/After Six Decades* (180×96cm). These two artworks depicted Maokong in the Mucha district of Taipei, and used a montage approach to illustrate the area's past and present.
· Published *Beautiful Traces – Those People, Those Things, Those Dreams*, a collection of 33 essays on Lion Art's 42 years of history, which was featured in *ArtCo Monthly*.

2014 | 67 years old —— · Presented solo exhibition, *Lee Shien Wen's Landscape in Ink— A View from Within*, at National Chengchi University's Art & Culture Center and published a book with the same title.
· Became a resident artist at National Taitung University and created *Searching for the Taiwan Cow-tail Fir on Winding Mountain Paths* and *Discovering the Hayata On Rolling Trails* (each 232×52.8cm in size). Began experimenting with the method of blank spaces and shifting temporal and spatial settings, exploring an aesthetic that integrated the intangible with the tangible. Art critic, Pai Shih-Ming, described them as two artworks created with the ancient horizontal narrative scroll style that was common in the ancient times, with each painting embodying multiple time frames and presented by flipping the artworks into hanging scrolls.

2015 | 68 years old —— · Invited by Artdoor Gallery in Taipei for *The Odyssey of Light - Solo Exhibition by Lee Shien-Wen*.

2016 | 69 years old —— · Created *Dreaming Back to Nature*, a nine-piece painting collection inspired by the Orchid Island, with each piece 130×65.5cm in size. The collection is a response to Reverend Egli's following words of lament, "I fear that I would not be able to handle the drastic changes of Orchid Island. However, even though the longing that I've once had for the island is now crushed, the beautiful, ethereal land inside of me will forever remain."

2017 | 70 years old —— · Published *Love Behind the Mountains*, a collection of writings and images on Taitung from 2005 to 2006, which was featured in *Wenhsun Magazine*.
· Invited by the National Museum of History to present, *Dreaming Back to Nature: Paintings by Lee Shien-Wen*.

出品圖錄／Catalog

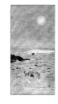
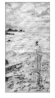

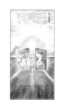
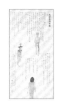
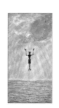

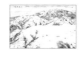
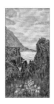
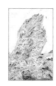

 海上飛虹｜062

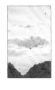 雲開日麗｜071

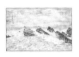 白浪吟｜064

 泉自奔忙月自遲｜072

 後山桃花源｜066

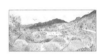 貓空百年茶事｜074

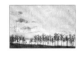 椰子海岸｜067

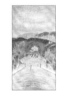 浮生／走過一甲子｜078

 螢光如織｜068

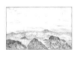 看見臺北（之一）｜080

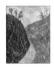 螢光如流｜069

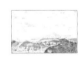 看見臺北（之二）｜081

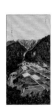 利稻曙色｜070

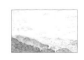 看見臺北（之三）｜081

出品圖錄／Catalog

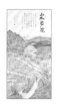

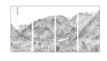

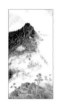
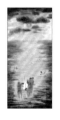
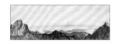
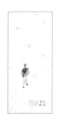
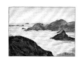
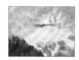
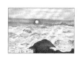
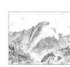
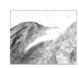
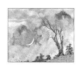

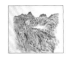
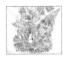
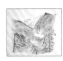

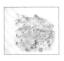

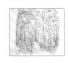
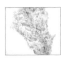
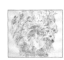
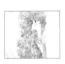
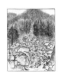
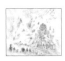
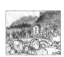
出品圖錄

出品圖錄／Catalog

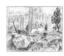

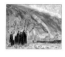

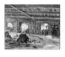

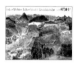

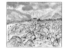

評述選錄／Selected Critiques

黃茜芳，〈有生有活有書有畫——李賢文〉，
藝境畫廊李賢文畫展小冊12月，2011（藝評）

江衍疇，〈淡寫悠遊，輕描深刻——李賢文的水墨途徑〉，
《今藝術》12月2012（藝評）

奚淞，〈斷裂與傳承〉，《人間清曠》雄獅圖書，2012（藝評）

李柏黎，〈繪畫、大自然、人文關懷〉，
《人間清曠》雄獅圖書，2012（序文）

吳方正，〈有情天地・清曠人間〉，
《人間福報》，12月11日，2012（藝評）

林銓居，〈筆墨靜好春秋後——讀李賢文的水墨畫〉，
《今藝術》，4月，2014（藝評）

陳寬育，〈李賢文的《雄獅》經驗與創作生涯〉，
《藝術認證》6月，2014（藝評）

阮愛惠，〈尊重每一個當下，勇敢為藝術奮鬥〉，
《人間福報》，5月27日，2016（報導）

白適銘，〈東海岸・一個人・天氣晴——
記李賢文水墨行旅展及其人文采風〉，
藝境畫廊李賢文畫展小冊11月，2015（藝評）

林永發，〈自然・生命・光照後山〉，
《後山有愛》，雄獅圖書，2017（序文）

封德屏，〈對這塊土地，深厚綿長的愛〉，
《後山有愛》，雄獅圖書，2017（序文）

黃長春，〈〔貓空百年茶事〕的山水之愛與人我之情〉，
《文山春秋增訂版》，雄獅圖書，2017（序文）

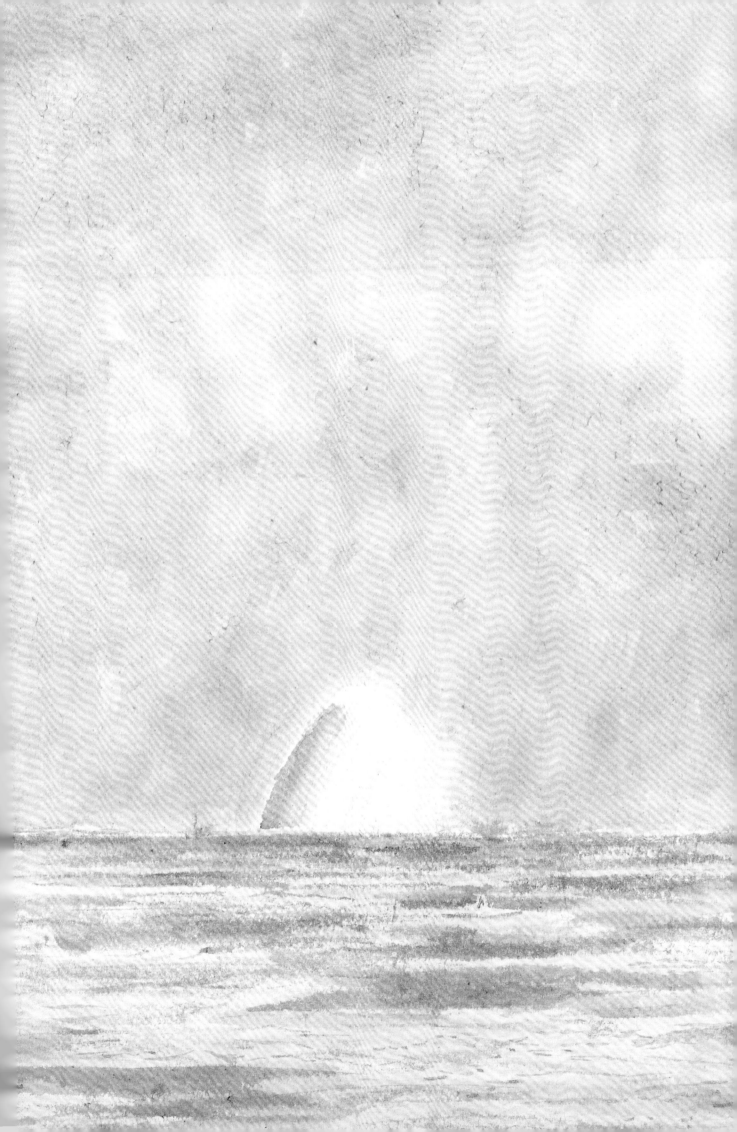

返回自然之夢——李賢文畫集
Dreaming Back to Nature: Paintings by Lee Shien-Wen

發行人｜陳登欽
Publisher: Chen Teng-Chin

出版者｜國立歷史博物館
Commissioner: The National Museum of History

10066 臺北市南海路四十九號／49 Nan-Hai Road, Taipei 10066, Taiwan R.O.C.
電話／Tel：＋886-2-23610270
傳真／Fax：＋886-2-23610171
網站／Web：www.nmh.gov.tw

編輯｜國立歷史博物館編輯委員會
Editorial Committee: Editorial Committee of the National Museum of History

主編／Chief Editor：江桂珍／Chiang Kuei-Chen
執行編輯／Executive Editor：蔡耀慶／Tsai Yao-Ching
英文翻譯／English Translators：廖蕙芬、林瑞堂／Liao Hui-Fen、Lin Juei-Tang
美術編輯／Art Editor：李柏宏／Lee Po-Hung
總務／Chief General Affairs：許志榮／Hsu Chih-Jung
主計／Chief Accountant：劉營珠／Liu Ying-Chu

製版印刷：永光彩色印刷股份有限公司
地址：235 新北市中和區建三路9號
電話：02-22237072

出版日期／Publication Date：中華民國106年8月／August 2017
版次／Edition：初版／First Edition
其他類型版本說明／Other Version：本書無其他類型版本／N/A

定價新臺幣／Price：NT$500
統一編號／GPN：1010600965
國際書號／ISBN：978-986-05-2967-8（平裝）

國家圖書館出版品預行編目（CIP）資料

返回自然之夢：李賢文畫集／
國立歷史博物館編輯委員會編輯.
-- 初版. -- 臺北市：史博館, 2017.08
面；　　　公分
ISBN 978-986-05-2967-8(平裝)

1.水墨畫　　2.畫冊
945.6　　　　106011545